Longman

PHOTO DICTIONARY

Marilyn S. Rosenthal
Daniel B. Freeman

Longman

Executive Editor: *Joanne Dresner*
Project Editor: *Penny Laporte*
Editorial Assistant: *Mary Monteleone*
Design Concept: *Gloria Moyer*
Interior and Cover Design: *Joseph DePinho*
Illustrator: *Joseph DePinho*
Maps: *J & R Art Services Inc.*
Photographer: *John Edelman*
Production: *Eduardo Castillo*

Longman Photo Dictionary

Longman Inc.
95 Church Street
White Plains, N.Y. 10601

Associated companies: Longman Group Ltd., London; Longman Cheshire Pty.,
Melbourne; Longman Paul Pty., Auckland; Copp Clark Pitman, Toronto;
Pitman Publishing Inc., New York

Library of Congress Cataloging-in-Publication Data

Rosenthal, Marilyn S., 1940–
 Longman photo dictionary.

 Includes index.
 Summary: An English language dictionary for
speakers of English as a second language, using
photographs and word lists and arranged according
to topics such as weather, money, post office,
family, occupations, sports, space, animals, etc.
 1. Picture dictionaries, English. 2. English
language—Text-books for foreign speakers. [1. Picture
dictionaries. 2. English language—Textbooks for
foreign speakers] I. Freeman, Daniel B., 1920–
II. Title
PE1629.R6 1987 423'.1 86-21304
ISBN 0-8013-0004-5

87 88 89 90 9 8 7 6 5 4 3 2 1

Distributed in the United Kingdom by Longman Group Ltd., Longman House,
Burnt Hill, Harlow, Essex CM20 2JE, England, and by associated companies,
branches and representatives throughout the world.

Printed in the U.S.A.

INTRODUCTION

The *Longman Photo Dictionary* presents a photographic panorama of life and language in North America. It is a vocabulary and conversation practice book which presents more than 2,000 vocabulary words in over 80 different semantic categories. The color photographs depicting modern American culture are presented either contextually (The Dining Room) or categorically (Emotions).

The *Longman Photo Dictionary* may also be used for alphabetizing, guessing games, listening practice, dictation, storytelling, categorizing, writing practice, compositions, debates, discussions, pair or group work. Indeed, the four skills of listening, speaking, reading and writing may be stimulated by each unit and may vary greatly depending on the language level and needs of your students.

The units are self-contained and are not presented in a developmental order. We encourage you to introduce the units in a way which suits your teaching situation best. You may, for example, want to group *Numbers* with *Money and Banking,* or present the rooms of the house with *Action at Home.*

A Mini Practice in each unit is designed to stimulate conversation and guide the students in describing the scenes or in using the vocabulary to communicate about their own lives and opinions. Some of the functions in the Mini Practices involve describing relationships and details, making comparisons, naming, labeling and communicating opinions and preferences. Many of the basic high frequency structures in conversational American English are spiraled and recur in the Mini Practices. The particular structure selected for each Mini Practice is intrinsically related to its generalized use in the context of the photographs and vocabulary in each unit. For example, the unit *Fast Foods and Snacks* uses the structure "Do you like hot dogs?", and asks the students to express their preferences.

Some of the conventions used in the Mini Practice are as follows: a slash mark as in "Yes, I do./No, I don't." indicates that students have an alternative and should give their opinions. The dots . . . indicate that students should create their own statements or questions and answers based on the model given.

We have intended to provide a basic resource of language and culture to be used on various levels as either a main or supplementary text. It is our hope that the photographs will excite you and your students and move you to emote and discuss each topic at hand. We welcome you to share your ideas with us.

Marilyn Rosenthal and Daniel Freeman

ACKNOWLEDGEMENTS

Special thanks go to:

- □ *Carol Taylor* and *Arley Gray* for perceiving the potential;
- □ *Joanne Dresner,* our editor, for her patience, perseverance, excellent judgment and good humor;
- □ *Penny Laporte,* project editor, for her extensive efforts and attention to detail;
- □ *Irwin Feigenbaum,* for his grammatical genius;
- □ *John Rosenthal, Ann Rosenthal* and *Peter Freeman* for their advice and participation;
- □ *Melody Miller* of Senator Kennedy's office, for her kindness and encouragement;
- □ *Frank Teti,* for his superb photographs of the Kennedy family;
- □ *Barbara Swartz,* for her outstanding listening skills;

 and

to the teachers and students all over the world who we hope will delight in the selected vocabulary and photographs of our culture as much as we have.

CONTENTS

NUMBERS

1 one	**11** eleven	**21** twenty-one	**1,000**	one thousand				
2 two	**12** twelve	**30** thirty	**10,000**	ten thousand				
3 three	**13** thirteen	**40** forty	**100,000**	one hundred thousand				
4 four	**14** fourteen	**50** fifty	**1,000,000**	one million				
5 five	**15** fifteen	**60** sixty	**+**	plus				
6 six	**16** sixteen	**70** seventy	**−**	minus				
7 seven	**17** seventeen	**80** eighty	**×**	times				
8 eight	**18** eighteen	**90** ninety	**÷**	divided by				
9 nine	**19** nineteen	**100** one hundred	**=**	equals				
10 ten	**20** twenty	**101** one hundred and one						

¼
one quarter/
one fourth

⅓
one third

½
one half

¾
three quarters/
three fourths

1
one

first second third fourth

100% one hundred percent

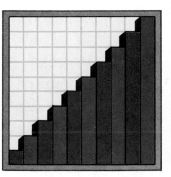

10% ten percent

How much is 4 + 6?	10
How much is 4 − 3?	1
How much is 4 × 4?	16
How much is 4 ÷ 2?	2

How much is 5 + 3? How much is 350 ÷ 2?
How much is 50 − 15??
How much is 13 × 30?

1

TIME

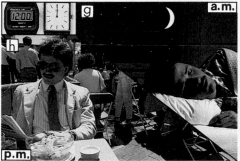

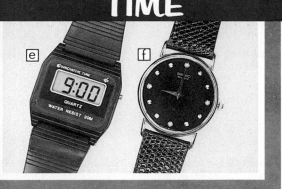

a. clock
b. hour hand
c. minute hand
d. face
e. (digital) watch
f. (analog) watch
g. twelve o'clock/midnight
h. twelve o'clock/noon
i. eight A.M./eight (o'clock) in the morning
j. eight P.M./eight (o'clock) at night
k. seven o'clock/seven
l. seven o five/five after seven
m. seven ten/ten after seven
n. seven fifteen/a quarter after seven
o. seven twenty/twenty after seven
p. seven twenty-five/twenty-five after seven
q. seven thirty/half past seven
r. seven thirty-five/twenty-five to eight
s. seven forty/twenty to eight
t. seven forty-five/a quarter to eight
u. seven fifty/ten to eight
v. seven fifty-five/five to eight

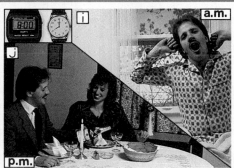

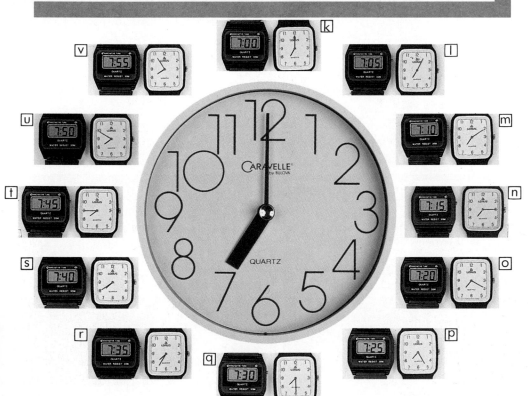

	What time is it? It's <u>seven o'clock</u>.		What time is it? It's

	What time is it? It's?

2

CALENDAR & HOLIDAYS
A 1988

A. Year

B. Months

January
February
March
April
May
June
July
August
September
October
November
December

C. Days of the Week

S Sunday
M Monday
T Tuesday
W Wednesday
T Thursday
F Friday
S Saturday

D. Holidays

1. New Year's Day
2. Valentine's Day
3. Washington's Birthday
4. St. Patrick's Day
5. Easter
6. Mother's Day
7. Memorial Day
8. Father's Day
9. Fourth of July/ Independence Day
10. Labor Day
11. Halloween
12. Thanksgiving
13. Christmas

B JANUARY
C
S	M	T	W	T	F	S
					①	2
3	4	5	6	7	8	9
10	11	12	13	14	15	16
17	18	19	20	21	22	23
24	25	26	27	28	29	30
31						

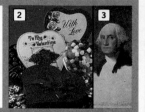

FEBRUARY
S	M	T	W	T	F	S
	1	2	3	4	5	6
7	8	9	10	11	12	13
⑭	⑮	16	17	18	19	20
21	22	23	24	25	26	27
28	29					

MARCH
S	M	T	W	T	F	S
		1	2	3	4	5
6	7	8	9	10	11	12
13	14	15	16	⑰	18	19
20	21	22	23	24	25	26
27	28	29	30	31		

APRIL
S	M	T	W	T	F	S
					1	2
③	4	5	6	7	8	9
10	11	12	13	14	15	16
17	18	19	20	21	22	23
24	25	26	27	28	29	30

MAY
S	M	T	W	T	F	S
1	2	3	4	5	6	7
⑧	9	10	11	12	13	14
15	16	17	18	19	20	21
22	23	24	25	26	27	28
29	㉚	31				

JUNE
S	M	T	W	T	F	S
			1	2	3	4
5	6	7	8	9	10	11
12	13	14	15	16	17	18
⑲	20	21	22	23	24	25
26	27	28	29	30		

JULY
S	M	T	W	T	F	S
					1	2
3	④	5	6	7	8	9
10	11	12	13	14	15	16
17	18	19	20	21	22	23
24	25	26	27	28	29	30
31						

AUGUST
S	M	T	W	T	F	S
	1	2	3	4	5	6
7	8	9	10	11	12	13
14	15	16	17	18	19	20
21	22	23	24	25	26	27
28	29	30	31			

No Holiday

SEPTEMBER
S	M	T	W	T	F	S
				1	2	3
4	⑤	6	7	8	9	10
11	12	13	14	15	16	17
18	19	20	21	22	23	24
25	26	27	28	29	30	

OCTOBER
S	M	T	W	T	F	S
						1
2	3	4	5	6	7	8
9	10	11	12	13	14	15
16	17	18	19	20	21	22
23	24	25	26	27	28	29
30	㉛					

NOVEMBER
S	M	T	W	T	F	S
		1	2	3	4	5
6	7	8	9	10	11	12
13	14	15	16	17	18	19
20	21	22	23	㉔	25	26
27	28	29	30			

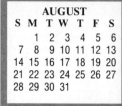

DECEMBER
S	M	T	W	T	F	S
				1	2	3
4	5	6	7	8	9	10
11	12	13	14	15	16	17
18	19	20	21	22	23	24
㉕	26	27	28	29	30	31

| January 10, 1989 | | | |
| 1/10/89 | | | |

| February 1, 1965 | May 5, 1990 | August 15, 1970 |
| | | |

| February 10, 1989 | November 21, 1975 | October 25, 1965 | April 2, 1947 |
| | | | |

WEATHER & SEASONS

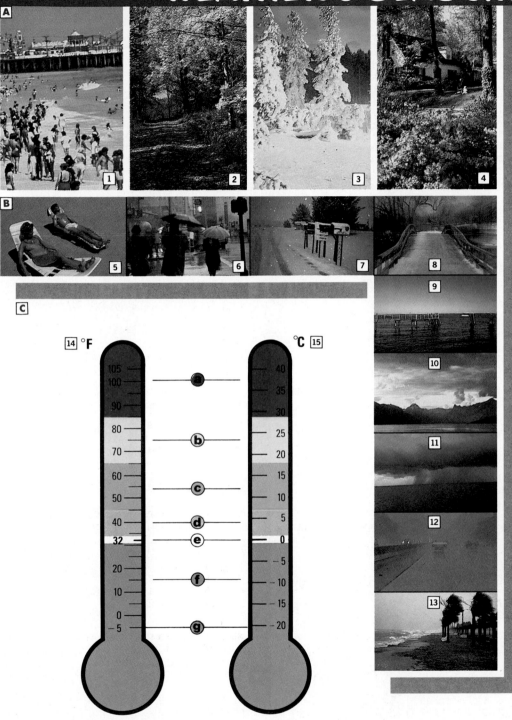

A. Seasons
1. summer
2. fall
3. winter
4. spring

B. Weather
5. sunny
6. rainy
7. snowy
8. icy
9. clear
10. cloudy
11. stormy
12. foggy
13. windy

C. Temperature
14. degrees Fahrenheit
15. degrees Celsius/
 degrees Centigrade
a. hot
b. warm
c. cool/chilly
d. cold
e. freezing
f. below freezing
g. five (degrees) below
 (zero)/minus twenty
 (degrees)

Is it hot out?
Yes, it's <u>90°</u>./No, it's <u>75°</u>.

Is it cold out?
Yes, it's

Is it warm out?
No, it's

Is it freezing out?
Yes, it's

Is it cool out?
No, it's

SHAPES & MEASUREMENTS

A. Cube
1. corner
2. top
3. front
4. edge
5. depth
6. height

B. Isosceles Triangle
7. obtuse angle
8. acute angle

C. Right Triangle
9. apex
10. hypotenuse
11. base
12. right angle

D. Square
13. side

E. Rectangle
14. width
15. length
16. diagonal

F. Circle
17. circumference
18. center
19. diameter
20. radius

G. Oval / Ellipse

H. Cylinder

I. Sphere

J. Lines
21. perpendicular
22. parallel
23. spiral

K. Measurements
24. yard stick
25. yard/
 0.914 meter
26. ruler
27. foot/
 0.305 meter
28. inch/
 2.54 centimeters

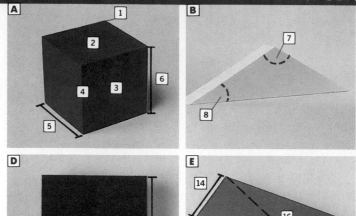
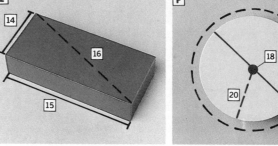
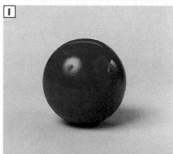
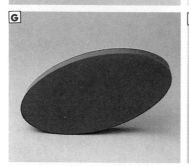
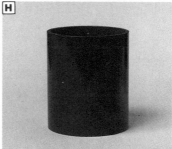
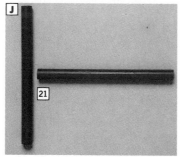
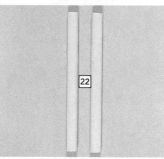
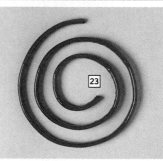

How many inches are in <u>one foot</u>?	<u>Twelve.</u>
How many feet are in <u>one yard</u>?	<u>Three.</u>

How many inches are in one yard?
How many feet are in two yards?
How many inches are in two feet?

5

MONEY & BANKING

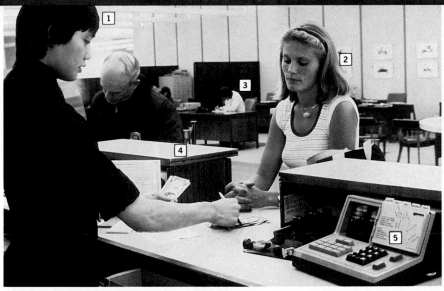

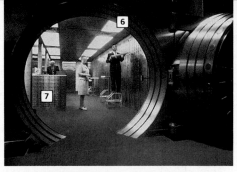

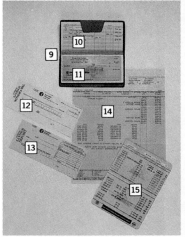

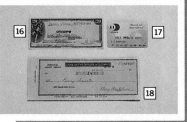

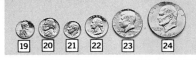

1. teller
2. customer
3. bank officer
4. counter
5. computer
6. bank vault
7. safe deposit vault
8. cash machine/
 automatic teller
9. checkbook
10. check register/
 record
11. check
12. withdrawal slip
13. deposit slip
14. monthly statement
15. bank book
16. traveler's check
17. credit card
18. money order
19. penny
20. nickel

21. dime
22. quarter
23. half dollar/fifty
 cent piece
24. silver dollar
25. dollar (bill)/
 one dollar
26. five (dollar bill)/
 five dollars
27. ten (dollar bill)/
 ten dollars
28. twenty (dollar bill)/
 twenty dollars
29. fifty (dollar bill)/
 fifty dollars
30. one hundred
 (dollar bill)/one
 hundred dollars

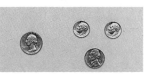

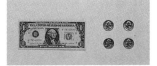

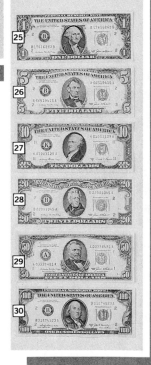

Do you have change
for a <u>ten</u>?
Sure. Here are two <u>fives</u>.

Do you have change
for a?
Sure. Here are four

Do you have change
for a?
Sure. Here are two and a

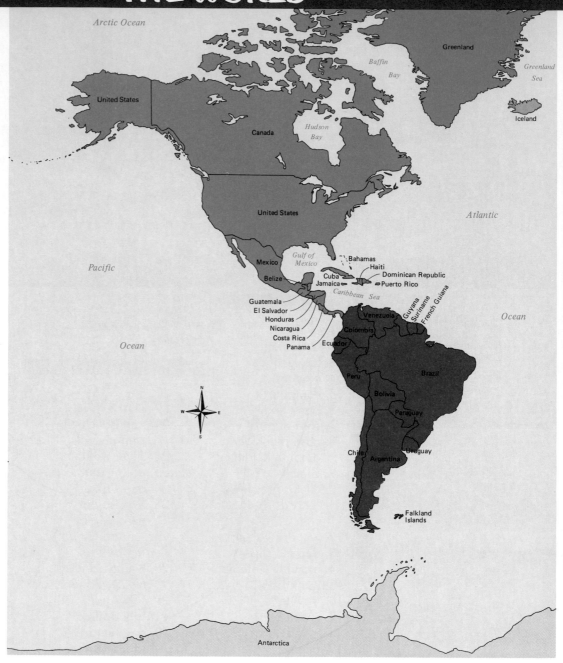

North America

South America

Europe

Asia

Africa

Australia

Antarctica

Where are you from?
I'm from <u>Brazil</u>.

Where are you from??
I'm from

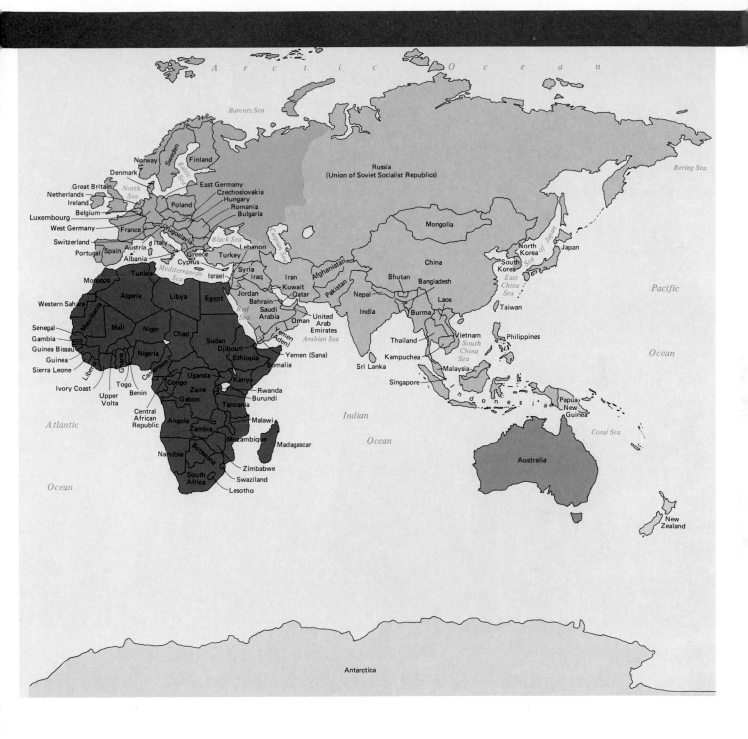

Where's France?
It's in

Where's Japan?
It's in

..........?

..........

THE UNITED STATES

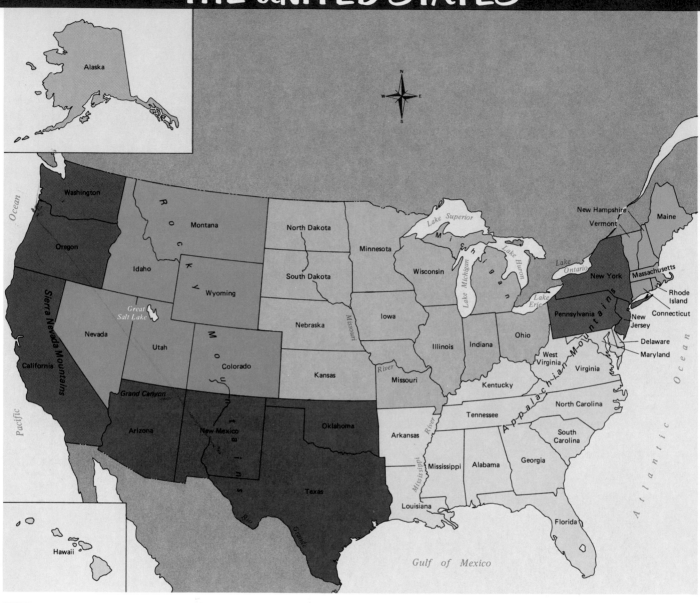

	New England/The East		Midwestern States/The Midwest
	Middle Atlantic States/The East		Rocky Mountain States
	Southern States/The South		Pacific Coast States/The West Coast
	Southwestern States/The Southwest		

N north
S south
E east
W west

Is Utah <u>north of</u> Arizona?
Yes, it is.

Is Utah <u>east of</u> Colorado?
No, it isn't. It's <u>west of</u> Colorado.

Is California south of Oregon??
..........

Is Missouri east of Kansas?
..........

CANADA

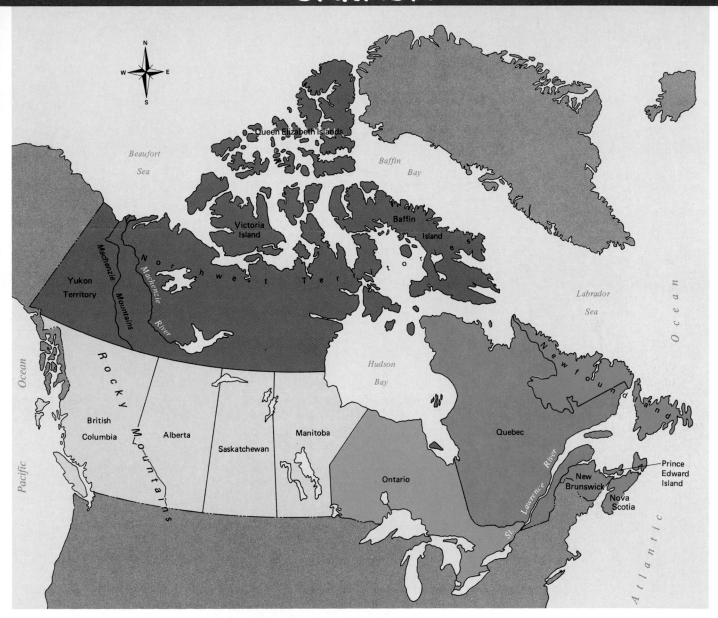

Map legend:
- Maritime Provinces
- Quebec
- Ontario
- Western Canada
- Northern Canada

Map labels: Beaufort Sea, Queen Elizabeth Islands, Baffin Bay, Victoria Island, Baffin Island, Mackenzie Mountains, Mackenzie River, Northwest Territories, Labrador Sea, Yukon Territory, Rocky Mountains, British Columbia, Alberta, Saskatchewan, Manitoba, Hudson Bay, Ontario, Quebec, Newfoundland, St. Lawrence River, New Brunswick, Prince Edward Island, Nova Scotia, Pacific Ocean, Atlantic Ocean

Is Ontario <u>west of</u> Quebec?
Yes, it is.

Is British Columbia <u>north of</u> Alberta?
No, it isn't. It's <u>west of</u> Alberta.

Is Newfoundland south of New Brunswick? ?
..........

Is Manitoba east of Saskatchewan?
..........

THE CITY

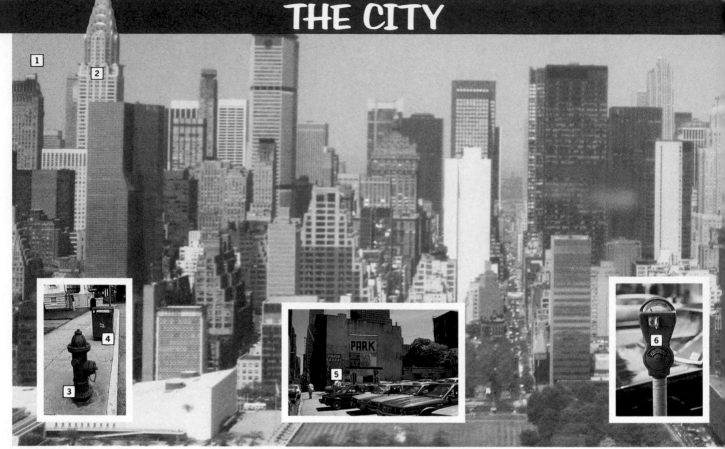

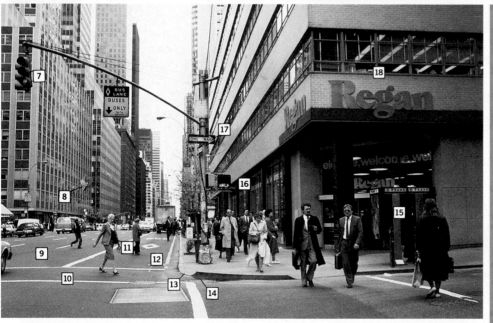

1. skyline
2. skyscraper
3. fire hydrant
4. trash can
5. parking lot
6. parking meter
7. traffic light
8. flag
9. street
10. crosswalk
11. pedestrian
12. bus lane
13. (street) corner
14. curb
15. phone booth/telephone booth
16. walk sign
17. one way (traffic) sign
18. office building

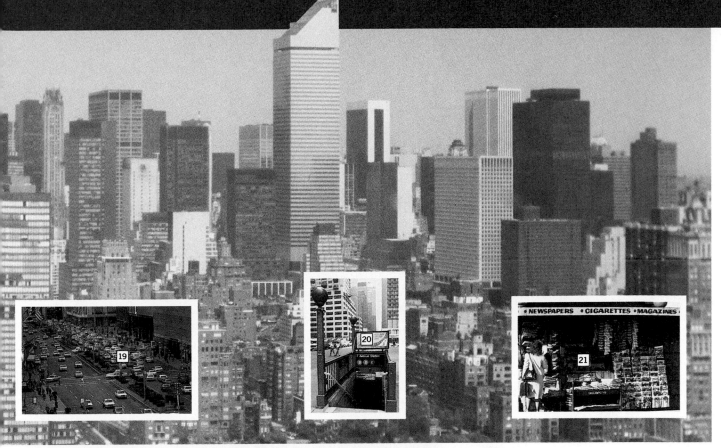

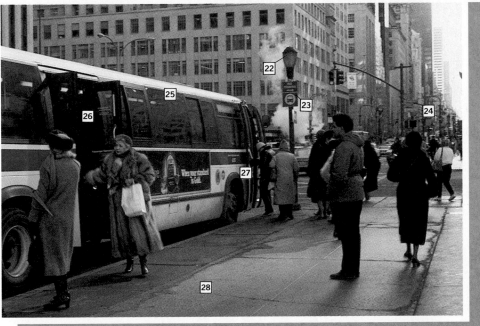

19. traffic (jam)
20. subway (entrance)
21. newsstand
22. street light
23. bus stop
24. street sign
25. bus
26. exit
27. passenger
28. sidewalk

5 Is there a parking lot near here?
Yes, there is./No, there isn't.

15 Is there a near here?
...........

23 Is there a near here?
...........

21?
...........

20?
...........

THE SUPERMARKET

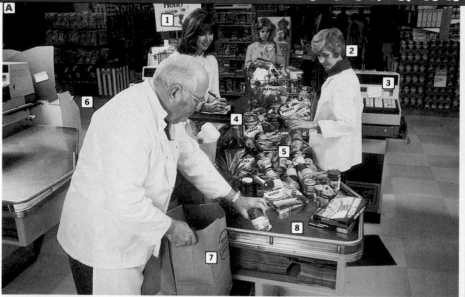

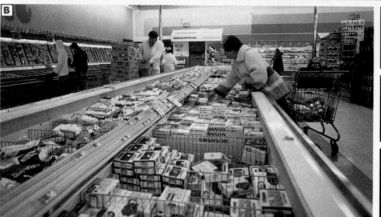

A. Check-out Area
1. customer/shopper
2. cashier
3. cash register
4. checkbook
5. groceries
6. packer
7. bag/sack
8. check-out counter

B. Frozen Foods
9. frozen vegetables
10. frozen dinner
11. frozen orange juice

C. Dairy
12. yogurt
13. cheese
14. eggs
15. margarine
16. butter
17. milk

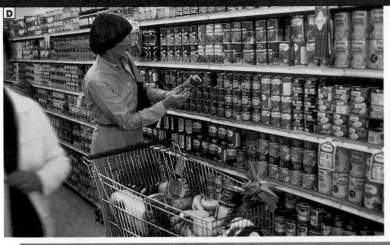

D. Canned Goods
18. tuna fish
19. soup

E. Meat and Poultry
20. bacon
21. roast
22. pork chops
23. chicken/roaster
24. ground meat
25. steak
26. lamb chops

F. Packaged Goods
27. bread
28. cereal
29. cookies
30. crackers
31. macaroni

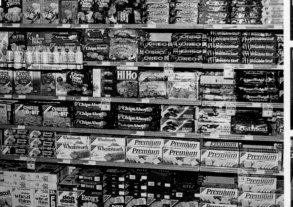

> **19** I need a can of soup.
> **28** I need a box of <u>cereal</u>
> **20** I need a pound of <u>bacon</u>.
> **6** I need a carton of <u>milk</u>.

18 I need a can of
31 I need a box of
24 I need a pound of
14 I need a carton of

FRUIT

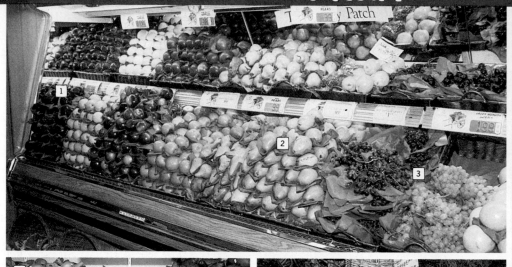

1. apples
2. pears
3. grapes
4. kiwis
5. mangoes
6. coconuts
7. avocados
8. bananas
9. nectarines
10. plums
11. cherries
12. apricots
13. lemons
14. limes
15. grapefruits
16. oranges
17. pineapples
18. papayas
19. peaches
20. strawberries
21. raspberries
22. blueberries
23. watermelons
24. honeydew melons
25. cantaloupes

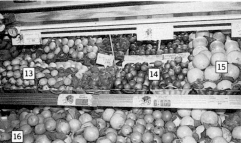

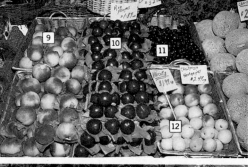

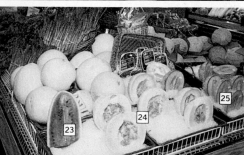

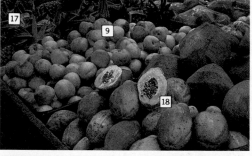

Do we need any apples? Yes, we need <u>some</u>./No, we don't need <u>any</u>.

Do we need any cherries? Do we need any grapes? ?

VEGETABLES

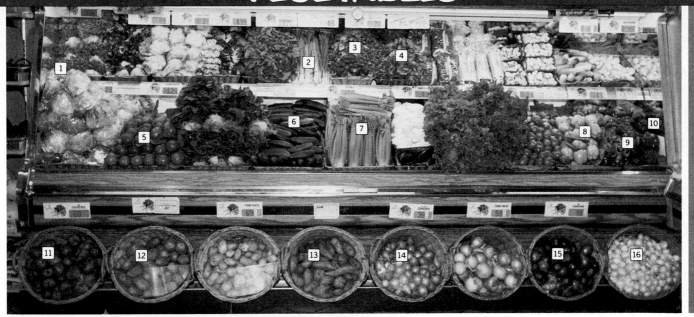

1. lettuce
2. green onions/ scallions
3. radishes
4. watercress
5. tomatoes
6. cucumbers
7. celery
8. yellow peppers
9. green peppers
10. red peppers
11. new potatoes
12. baking potatoes
13. sweet potatoes
14. onions
15. red onions
16. pearl onions

17. cauliflower
18. spinach
19. garlic
20. artichokes
21. green beans/ string beans
22. eggplants
23. carrots
24. asparagus
25. broccoli
26. corn
27. ginger
28. parsnips
29. cabbage
30. leeks
31. turnips
32. dill

[14] I'd like a pound of <u>onions</u>.
[7] I'd like a bunch of <u>celery</u>.
[1] I'd like a head of <u>lettuce</u>.

[5] I'd like a pound of
[32] I'd like a bunch of
[29] I'd like a head of

THE MENU

A. Appetizers
1. tomato juice
2. fruit cup/fruit cocktail
3. shrimp cocktail

B. Soup and Salad
4. soup
5. (tossed) salad

C. Main Courses / Entrées
6. steak
7. baked potato
8. (dinner) roll
9. roast beef
10. stuffed tomatoes
11. pork chops
12. carrots
13. spaghetti and meatballs
14. roast chicken
15. green beans
16. peaches
17. fish
18. broccoli

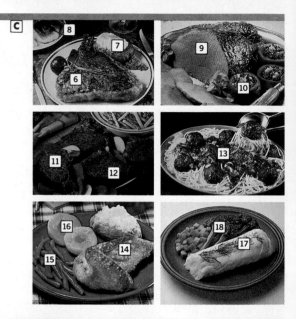

D. Desserts
19. apple pie
20. chocolate cake
21. ice cream
22. jello

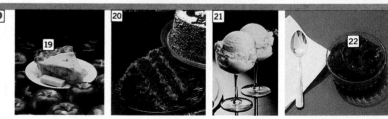

E. Beverages
23. coffee
24. tea

Would you like <u>tea</u> or <u>coffee</u>?
I'd like <u>tea</u>./I'd like <u>coffee</u>.

Would you like soup or salad?
I'd like

Would you like or?
..........

17

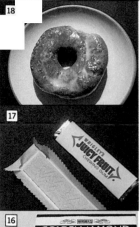
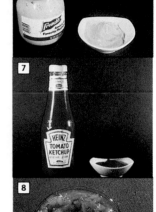

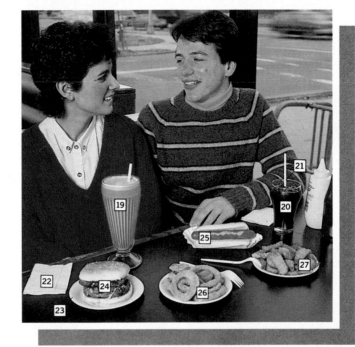

1. hero/submarine sandwich
2. roast beef sandwich
3. pizza
4. fried clams
5. fried chicken
6. mustard
7. ketchup

8. relish
9. pickles
10. onions
11. potato chips
12. tortilla chips
13. pretzels
14. popcorn

15. peanuts
16. candy bar/chocolate
17. (chewing) gum
18. donut
19. milk shake
20. soft drink/soda
21. straw

22. (paper) napkin
23. (paper) plate
24. hamburger
25. hot dog
26. onion rings
27. french fries

[25] Do you like <u>hot dogs</u>? Yes, I do./No, I don't.
[9] Do you like <u>pickles</u>? Yes, I do./No, I don't.

[27] Do you like?
[13] Do you like?

[11]?
[15]?

THE POST OFFICE

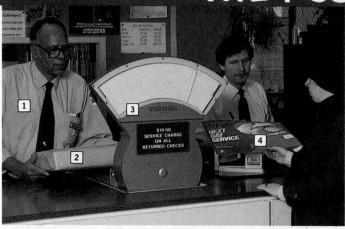

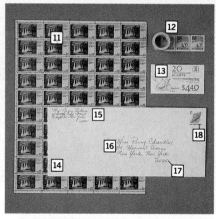

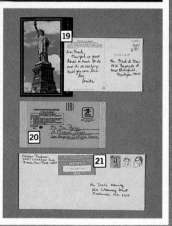

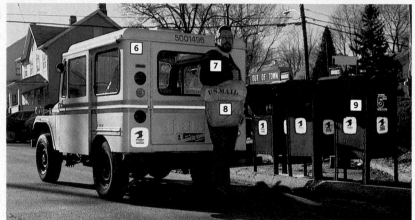

1. postal clerk
2. package/parcel
3. scale
4. express mail
5. mail slot
6. mail truck
7. mail carrier
8. mailbag
9. mailbox
10. stamp machine
11. sheet of stamps
12. roll of stamps
13. book of stamps
14. envelope
15. return address
16. address
17. zip code
18. stamp
19. (picture) postcard
20. return receipt
21. certified mail

What's Dale Harvey's address?
828 Chauncey Street. Baltimore, Maryland.

What's his zip code?
21217.

What's your address?
..........

What's your zip code?
..........

THE OFFICE

1. secretary
2. (desk) lamp
3. index file/Rolodex
4. pencil holder
5. (electric) pencil sharpener
6. typewriter
7. typing paper
8. tape dispenser
9. tape/Scotch tape
10. stapler
11. in box
12. out box
13. paper clip holder
14. stationery
15. wastepaper basket
16. file cabinet
17. file folder
18. bulletin board
19. receptionist
20. telephone/switchboard
21. note pad
22. message pad
23. desk calendar
24. desk
25. (ball point) pen
26. pencil
27. eraser
28. rubber band
29. paper clip
30. staple
31. photocopier/Xerox machine

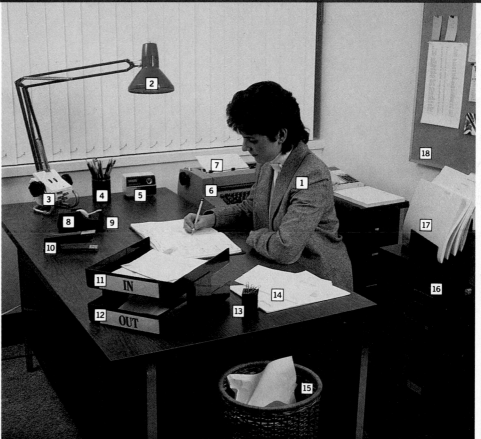

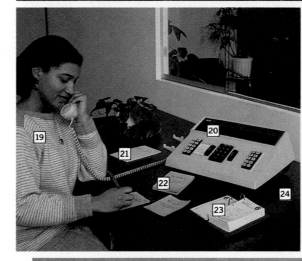

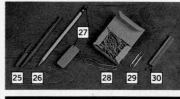

Where's the stapler?	It's <u>on</u> the desk.
Where's the typing paper?	It's <u>in</u> the typewriter.
Where's the pencil sharpener?	It's <u>next to</u> the pencil holder.

Where's the in box?	It's the desk.
Where's the paper clip?	It's the paper clip holder.
Where's the tape dispenser?	It's the stapler.
Where's the wastepaper basket?	It's the desk.

OCCUPATIONS

1. construction worker
2. bricklayer/mason
3. carpenter
4. painter
5. window washer
6. sanitation worker
7. truck driver
8. mechanic
9. welder
10. electrician
11. plumber
12. firefighter
13. police officer
14. letter carrier
15. fisherman
16. farmer
17. florist
18. grocer
19. butcher
20. baker
21. chef/cook
22. waiter
23. waitress

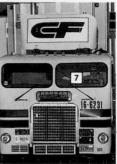
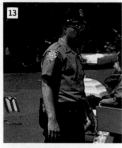

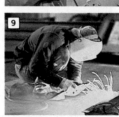

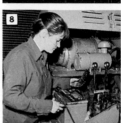

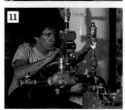
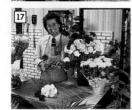
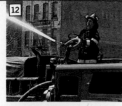
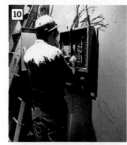
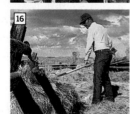
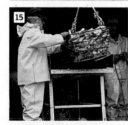
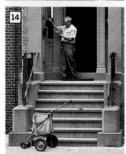
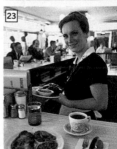
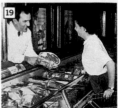
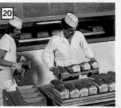
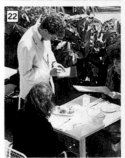
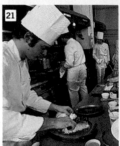
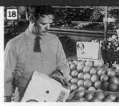

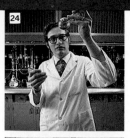

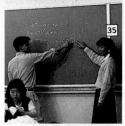

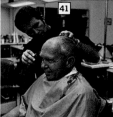

24. scientist
25. doctor/pediatrician
26. nurse
27. dentist
28. (dental) hygienist
29. optometrist
30. veterinarian
31. pharmacist
32. newscaster
33. journalist
34. computer technician
35. teacher
36. architect
37. secretary
38. teller
39. salesperson
40. hairdresser
41. barber
42. tailor
43. seamstress
44. model
45. photographer
46. artist

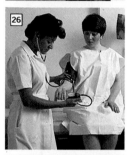

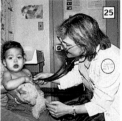

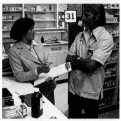

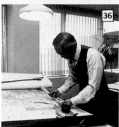

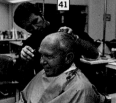

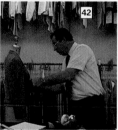

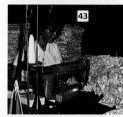

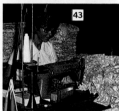

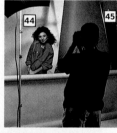

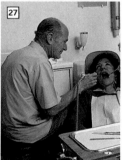

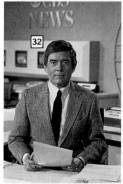

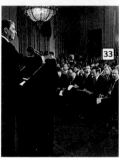

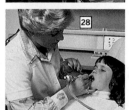

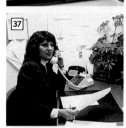

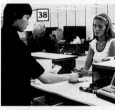

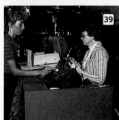

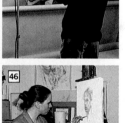

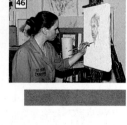

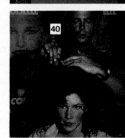

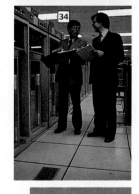

Would you like to be a <u>carpenter</u>?
Yes, I would./No, I wouldn't. I'd rather
be a <u>painter</u>.

Would you like to be a?
..........

Would you like to be a?
..........

..........?
..........

THE BODY

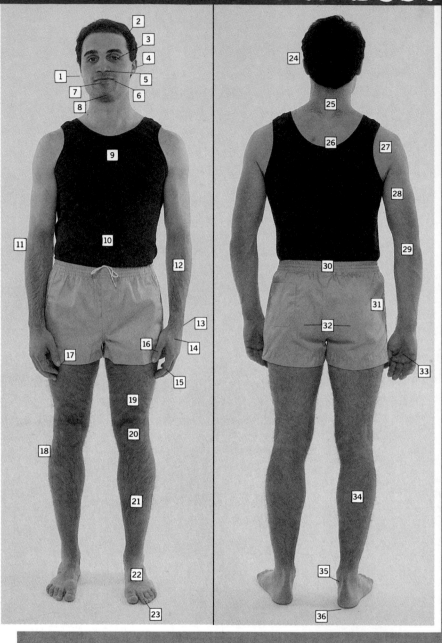

1. face
2. hair
3. eye
4. ear
5. nose
6. mouth
7. lip
8. chin
9. chest
10. stomach
11. arm
12. forearm
13. wrist
14. hand
15. finger
16. thumb
17. nail
18. leg
19. thigh
20. knee
21. shin
22. foot
23. toe
24. head
25. neck
26. back
27. shoulder
28. upper arm
29. elbow
30. waist
31. hip
32. buttocks
33. palm
34. calf
35. ankle
36. heel

37. blonde
38. brunette
39. redhead
40. forehead
41. temple
42. eyebrow
43. eyelid
44. eyelash
45. pupil
46. cheek
47. mustache
48. tooth
49. beard

50. tongue
51. brain
52. artery
53. vein
54. throat
55. lung
56. heart
57. liver
58. gall bladder
59. small intestine
60. large intestine
61. fatty tissue

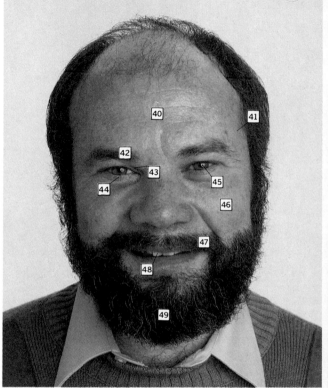

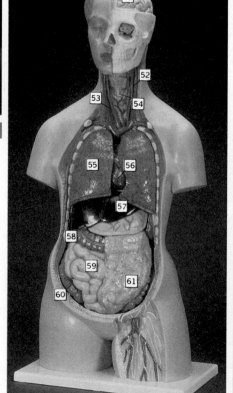

| What's that called? | 59 | The <u>small intestine</u>. |

What's that called?	57	The
What's that called?	60	The
...........?	56
...........?	51

24

COSMETICS & TOILETRIES

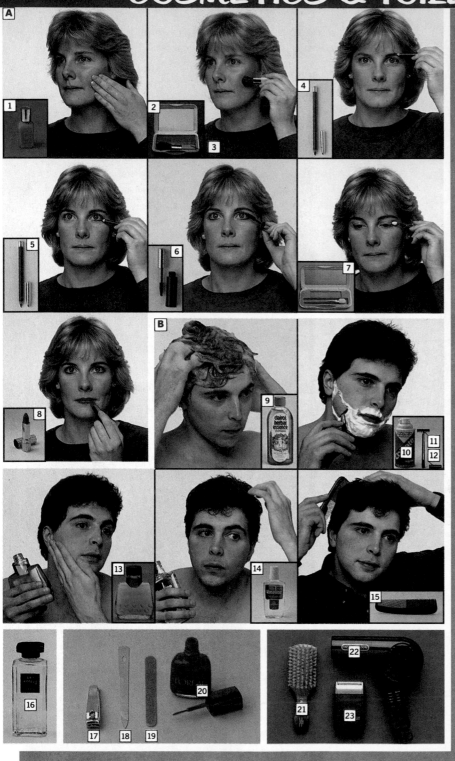

A. Cosmetics
1. base/foundation
2. blush/rouge
3. brush
4. eyebrow pencil
5. eyeliner
6. mascara
7. eye shadow
8. lipstick

B. Toiletries
9. shampoo
10. shaving cream
11. razor
12. razor blade
13. after-shave (lotion)
14. hair tonic
15. comb
16. cologne
17. nail clipper
18. nail file
19. emery board
20. nail polish
21. (hair) brush
22. hair dryer
23. electric shaver

| What's she doing? | 8 She's putting on <u>lipstick</u>. |
| What's he doing? | 13 He's putting on <u>after-shave</u>. |

What's she doing? 6 She's putting on? 7

What's he doing? 14 He's putting on? 2

ACTION AT HOME

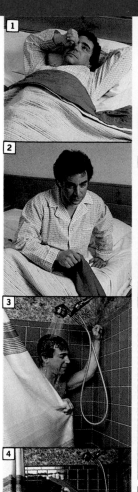

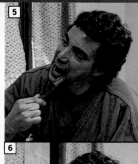

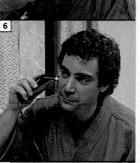

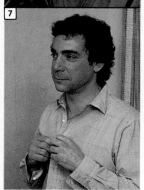

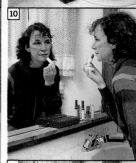

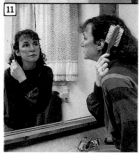

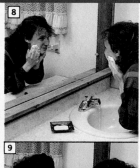

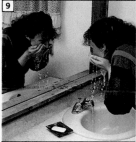

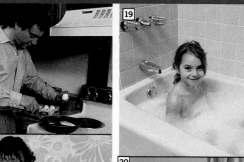

5. brush your teeth
6. shave
7. get dressed

1. wake up
2. get up
3. take a shower
4. dry off

8. wash your face
9. rinse your face
10. put on makeup
11. brush your hair

12. cook
13. eat
14. drink
15. sweep
16. dust
17. watch (TV)
18. listen

19. take a bath
20. comb your hair
21. go to bed
22. sleep

What does he do everyday?	**2** He <u>gets</u> up.
What does she do everyday?	**8** She <u>washes</u> her face.
What does she do everyday?	**21** She <u>goes</u> to bed.

What does she do everyday?	**20** She her hair.
What does he do everyday?	**5** He his teeth.
...........?	**6**

26

ACTION AT THE GYM

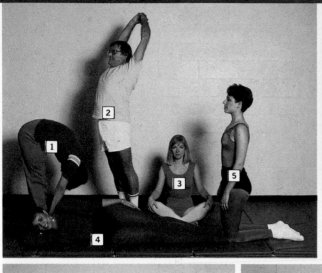

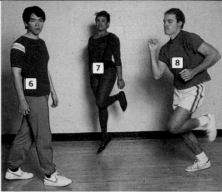

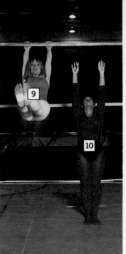

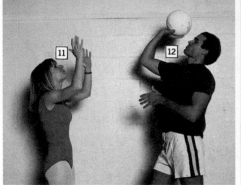

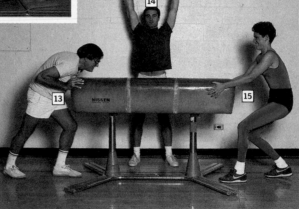

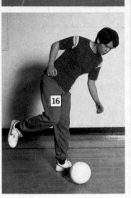

1. bend	5. kneel	9. swing	13. push
2. stretch	6. walk	10. reach	14. lift
3. sit	7. hop	11. catch	15. pull
4. lie down	8. run	12. throw	16. kick

What's he doing?	[2]	He's stretching.
What's she doing?	[7]	She's hopping.

What's he doing?	[8]	He's
What's she doing?	[5]	She's
...........?	[1]
...........?	[9]

ACTION AT SCHOOL

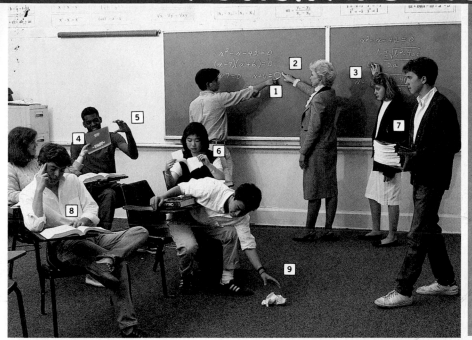

1. write
2. teach
3. erase
4. give
5. take
6. tear up
7. carry
8. read
9. pick up
10. paint
11. sculpt
12. cut

13. draw
14. smile
15. laugh
16. point
17. touch
18. frown
19. go up
20. wave
21. stand
22. go down
23. fall

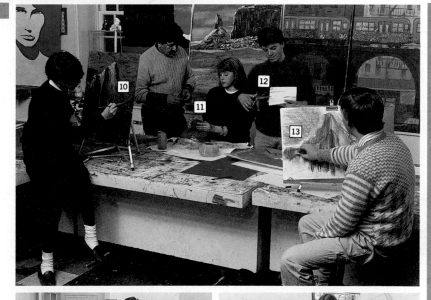

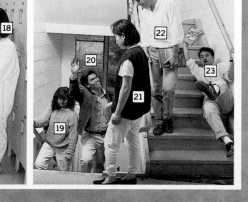

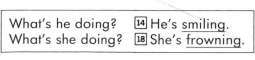

| What's he doing? | 14 He's <u>smiling</u>. |
| What's she doing? | 18 She's <u>frowning</u>. |

What's he doing? 13 He's
What's she doing? 10 She's
...........? 8
...........? 11

THE DOCTOR

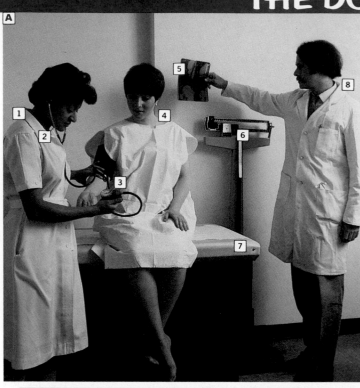

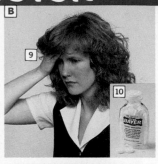
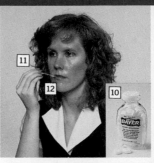

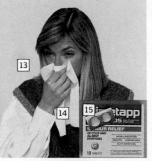
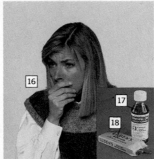

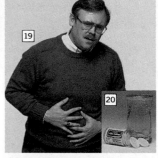
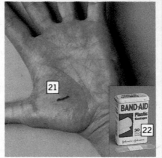

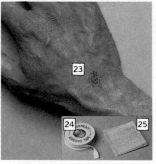

A. The Doctor's Office

1. nurse
2. stethoscope
3. blood pressure gauge
4. patient
5. x-ray
6. scale
7. examination table
8. doctor

B. Sickness and Medicine

9. headache
10. aspirin
11. fever

12. thermometer
13. cold
14. tissue/Kleenex
15. cold tablets
16. cough
17. cough syrup
18. cough drops
19. stomachache
20. antacid/Alka Seltzer
21. cut
22. Band-Aid
23. scratch
24. adhesive tape
25. bandage/gauze
26. prescription

What do you do for a <u>headache</u>?
Take <u>aspirin</u>.

What do you do for a?
Take Alka Seltzer.

What do you do for a?
Take cough drops.

What do you do for a?
Take cold tablets.

THE DENTIST

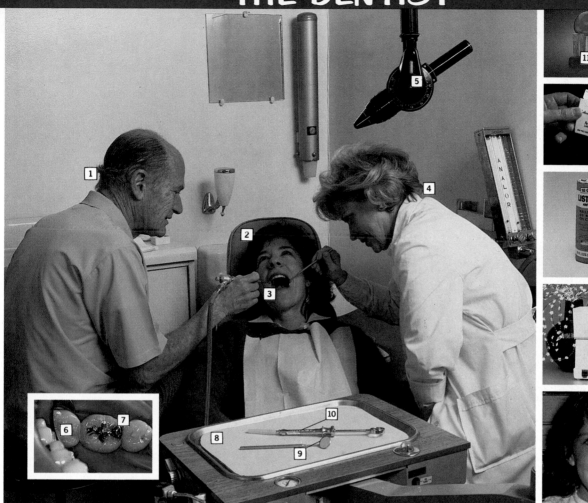

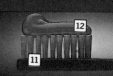

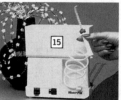

1. dentist
2. patient
3. drill
4. dental assistant
5. x-ray machine
6. tooth

7. filling
8. tray
9. mirror
10. Novocain
11. toothbrush
12. toothpaste

13. dental floss
14. mouthwash
15. Water Pik
16. missing tooth
17. overbite
18. braces

16 Have you ever had a <u>missing tooth</u>?
Yes, I have./No, I haven't.

7 Have you ever had a?
..........

17 Have you ever had an?
..........

18 Have you ever had?
..........

THE FAMILY

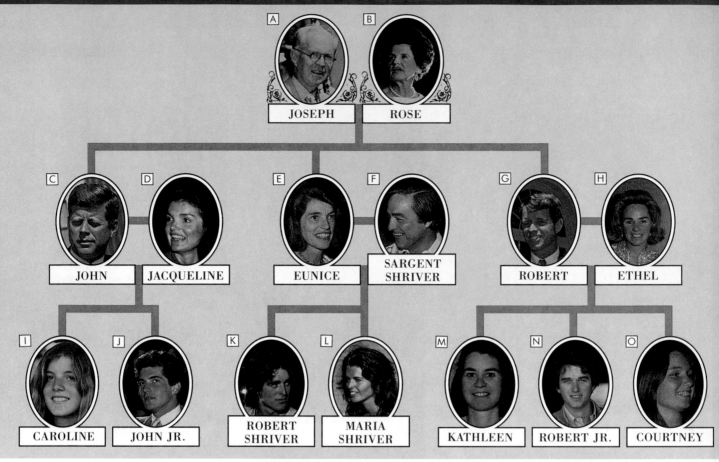

THE KENNEDY FAMILY

husband and wife A & B
father and son A & C
father and daughter A & E
mother and son B & C
mother and daughter B & E
brother and sister C & E
brothers C & G
sisters M & O
brother-in-law and sister-in-law C & H
brothers-in-law C & F
sisters-in-law E & H
father-in-law and son-in-law A & F
father-in-law and daughter-in-law A & H

mother-in-law and son-in-law B & F
mother-in-law and daughter-in-law B & H
parents and children A B & C E G
grandparents and grandchildren A B & I J
grandfather and grandson A & J
grandfather and granddaughter A & I
grandmother and grandson B & J
grandmother and granddaughter B & I
uncle and nephew C & K
uncle and niece C & L
aunt and nephew D & K
aunt and niece D & L
cousins I J & K L & M N O

Rose is Joseph's <u>wife</u>.
John is Joseph's <u>son</u>.

Rose is John's
Caroline is Jacqueline's

John is Caroline's
..........

31

EMOTIONS

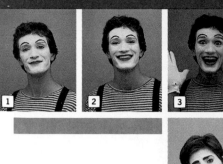

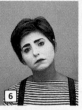

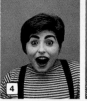

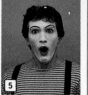

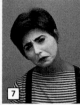

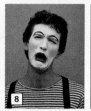

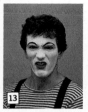

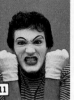

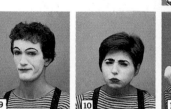

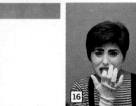

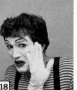

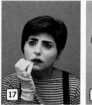

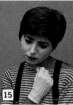

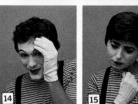

1. pleased
2. happy
3. ecstatic
4. surprised
5. shocked
6. sad
7. miserable
8. grieving
9. displeased
10. angry/mad
11. furious
12. annoyed
13. disgusted
14. embarrassed
15. ashamed
16. nervous
17. worried
18. scared/afraid
19. determined
20. proud
21. smug
22. shy
23. bored
24. confused
25. suspicious

Is he <u>happy</u>? [2] Yes, he is.
Is she <u>happy</u>? [6] No, she isn't. She's <u>sad</u>.

Is he pleased? [1] Is he worried? [11]
Is she angry? [16] Is she bored? [23]

OPPOSITES

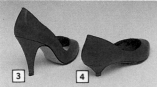

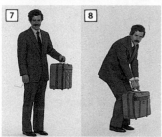

1. neat
2. messy

3. high
4. low

5. loose
6. tight

7. light
8. heavy

9. long
10. short

11. good
12. bad

13. tall
14. short

15. young
16. old

17. clean
18. dirty

19. pretty
20. ugly

21. wet
22. dry

23. straight
24. curly

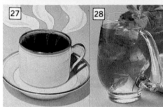

25. fast
26. slow

27. hot
28. cold

29. open
30. closed

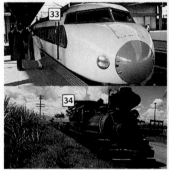

31. full
32. empty

33. new
34. old

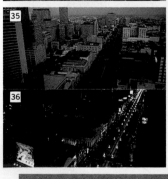

35. light
36. dark

37. straight
38. crooked

39. wide
40. narrow

41. thick
42. thin

43. soft
44. hard

45. smooth
46. rough

47. over
48. under

Is it <u>hot</u> or <u>cold</u>?	27 It's <u>hot</u>.
Is she <u>wet</u> or <u>dry</u>?	22 She's <u>dry</u>.

Is it neat or messy? 1 It's
Is she clean or dirty? 18 She's
Is it straight or crooked? 38
Is she young or old? 16
..........

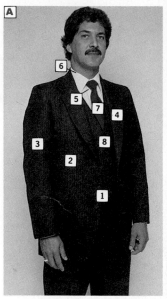

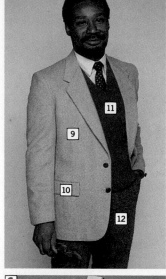

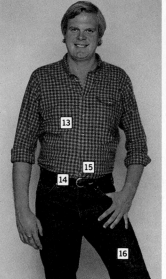

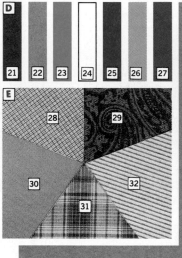

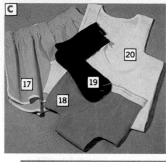

A. The Suit
1. suit
2. jacket
3. sleeve
4. lapel
5. shirt
6. collar
7. tie
8. vest

B. Casual Wear
9. sport jacket/sport coat

10. pocket
11. sweater
12. slacks/pants
13. sport shirt
14. belt
15. (belt) buckle
16. jeans

C. Underwear
17. boxer shorts
18. briefs/Jockey
 shorts

19. sock
20. undershirt/
 t-shirt

D. Colors
21. brown
22. gray
23. green
24. white
25. red
26. tan
27. blue

E. Patterns
28. checked
29. paisley
30. solid
31. plaid
32. striped

22 Do you have a <u>gray</u> suit? Yes, I do./No, I don't.
7 Do you have a green <u>tie</u>? Yes, I do./No, I don't.

21 Do you have a suit? 9 Do you have a blue?
30 Do you have a sweater? 5 Do you have a striped?

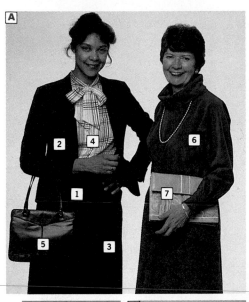

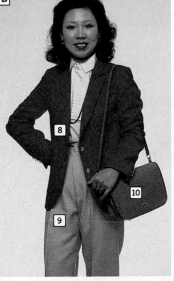

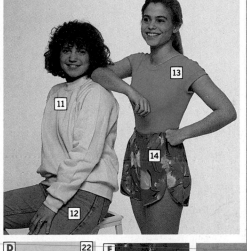

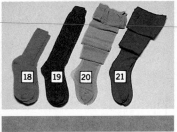

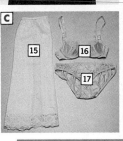

A. The Suit and Dress
1. suit
2. jacket
3. skirt
4. blouse
5. handbag
6. dress
7. clutch bag

B. Casual Wear
8. blazer

9. slacks/pants
10. shoulder bag
11. sweatshirt
12. jeans
13. t-shirt
14. shorts

C. Underwear
15. (half) slip
16. bra
17. underpants/panties

18. sock
19. knee sock
20. panty hose
21. tights

D. Colors
22. pink
23. yellow
24. purple
25. orange
26. turquoise

27. black
28. beige

E. Patterns
29. print
30. flowered
31. polka dot

What's she wearing? [11] She's wearing a <u>yellow sweatshirt</u>.
What's she wearing? [14] She's wearing <u>flowered shorts</u>.

What's she wearing? [13] She's wearing a
What's she wearing? [12] She's wearing

What's she wearing? [9] She's wearing
What's she wearing? [8] She's wearing a...........

MEN'S & WOMEN'S WEAR

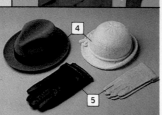

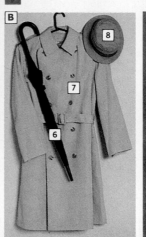

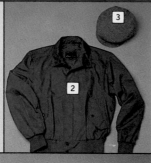

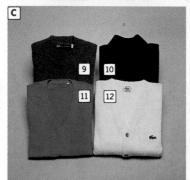

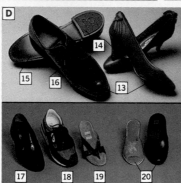

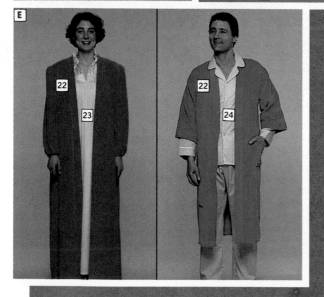

A. Outerwear
1. coat
2. jacket
3. cap
4. hat
5. glove

B. Rainwear
6. umbrella
7. raincoat/trench coat
8. rain hat

C. Sweaters
9. crewneck
10. turtleneck
11. V-neck
12. cardigan

D. Footwear
13. shoe
14. heel
15. sole
16. shoelace
17. loafer
18. sneaker
19. sandal

20. slipper
21. boot

E. Nightwear
22. robe
23. nightgown
24. pajamas

always ● often ▦ rarely ⊙ never ○

[4]	Do you ever wear a <u>hat</u>?	Yes, I <u>always</u> wear one.
[1]	Do you ever wear a <u>coat</u>?	Yes, I <u>often</u> wear one.
[3]	Do you ever wear a <u>cap</u>?	No, I <u>rarely</u> wear one.
[22]	Do you ever wear a <u>robe</u>?	No, I <u>never</u> wear one.

[7]	Do you ever wear a? wear one.
[10]	Do you ever wear a? wear one.
[12]?
[2]?

ACCESSORIES

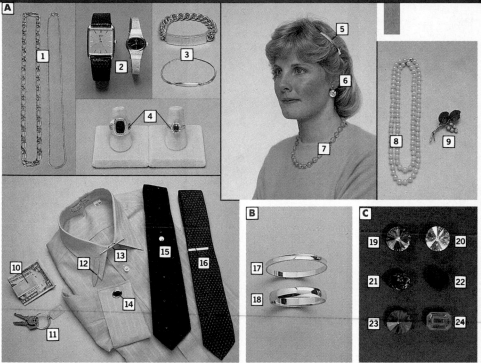

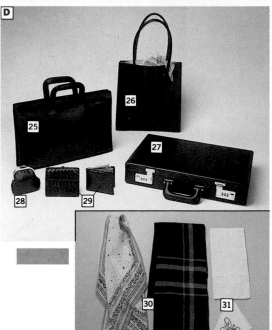

A. Jewelry
1. chain
2. watch
3. bracelet
4. ring
5. barrette
6. earring
7. necklace
8. pearls
9. pin
10. money clip
11. key ring
12. stay
13. collar bar
14. cuff link
15. tiepin/tie tack
16. tie bar/tie clip

B. Metals
17. gold
18. silver

C. Gems
19. topaz
20. diamond
21. amethyst
22. ruby
23. sapphire
24. emerald

D. Accessories
25. briefcase
26. tote bag
27. attaché case
28. change purse
29. wallet
30. scarf
31. handkerchief

Is that a gold chain?	1	Yes, it is.
Is that a gold bracelet?	3	No, it's not. It's a silver bracelet.

Is that a gold watch? 2 Is that a silver money clip? 10
Is that a silver earring? 6 Is that a gold tiepin? 15

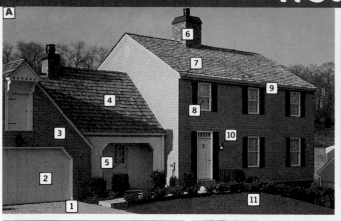

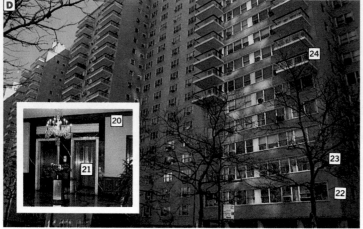

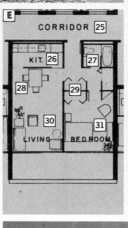

A. Two-Story House
1. driveway
2. garage door
3. garage
4. roof
5. side door
6. chimney
7. gutter
8. window
9. shutter

10. (porch) light
11. lawn

B. Ranch House
12. front walk
13. doorknob
14. front door

C. Two-Family House/Duplex
15. antenna

16. upstairs apartment
17. downstairs apartment
18. mailbox
19. (front) steps

D. Apartment Building
20. lobby
21. elevator
22. first floor
23. second floor

24. balcony

E. Floor Plan
25. hall/corridor
26. kitchen
27. bathroom
28. dining room
29. closet
30. living room
31. bedroom

Have you ever lived in <u>an apartment building</u>?
Yes, I have./No, I haven't.

Have you ever lived in a two-story house?
...........

Have you ever lived in a two-family house?
...........

Have you ever lived in a ranch house?
...........

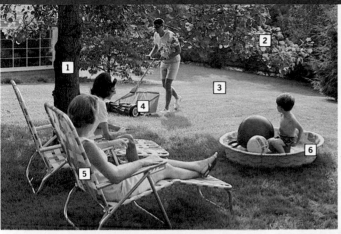
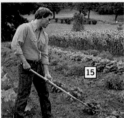

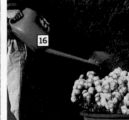

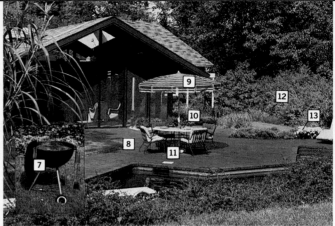

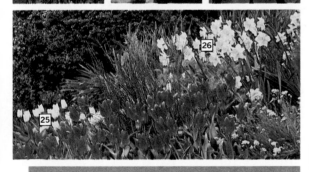

1. tree
2. leaf
3. lawn/grass
4. lawn mower
5. lounge chair
6. wading pool
7. barbecue
8. patio
9. umbrella
10. (patio) table
11. (patio) chair
12. bush
13. flower bed

14. hedge
15. vegetable garden
16. watering can
17. rake
18. trowel
19. rose
20. daisy
21. azalea
22. snapdragon
23. pansy
24. geranium
25. tulip
26. daffodil

Do you like <u>roses</u>?
Yes, I do./No, I don't. I like <u>tulips</u> better.

Do you like daisies? Do you like snapdragons?
..........

Do you like azaleas? ?
..........

THE LIVING ROOM

1. couch/sofa	6. coffee table	11. bookcase	16. planter	21. mantel
2. cushion	7. end table	12. book	17. flowers	22. picture
3. (throw) pillow	8. lamp	13. window	18. vase	23. (picture) frame
4. club chair	9. lamp shade	14. drape	19. fireplace	24. side table
5. love seat	10. wall unit	15. plant	20. (fireplace) screen	

25. ottoman	
26. rug	
27. floor	
28. ceiling	

The vase is <u>in front of</u> the window.
The wall unit is <u>behind</u> the couch.
The book is <u>on</u> the side table.

The planter is the drapes.
The lamp is the end table.
The side table is the ottoman.

The fireplace screen is the fireplace.
The coffee table is the rug.

THE DINING ROOM

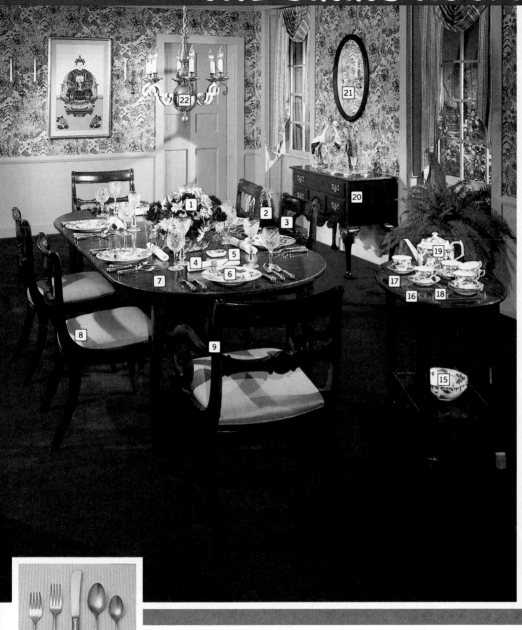

1. centerpiece
2. wine glass
3. water glass
4. napkin ring
5. napkin
6. plate
7. (dining room) table
8. chair
9. armchair
10. (salad) fork
11. (dinner) fork
12. knife
13. soupspoon
14. teaspoon
15. (serving) bowl
16. server
17. cup
18. saucer
19. teapot
20. sideboard/buffet
21. mirror
22. chandelier

Where is the salad fork?
It's <u>to the left of</u> the dinner fork.

Where is the teaspoon?
It's <u>to the right of</u> the soupspoon.

Where is the soupspoon?
It's the teaspoon.

Where is the dinner fork?
It's the salad fork.

Where is the knife?
It's the soupspoon.

THE BEDROOM

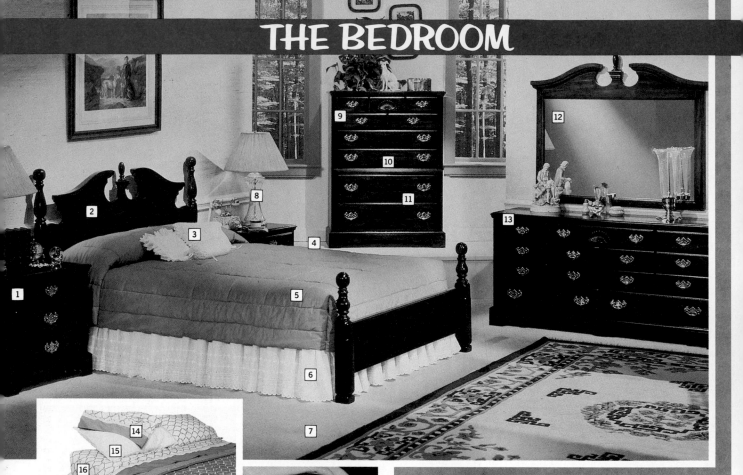

1. night table/nightstand
2. headboard
3. throw pillow
4. bed
5. bedspread
6. dust ruffle
7. carpet
8. lamp
9. chest (of drawers)
10. drawer
11. handle/pull
12. mirror
13. dresser
14. pillowcase
15. pillow
16. (fitted) sheet
17. (flat) sheet
18. comforter/quilt
19. electric blanket
20. (heat) control
21. mattress
22. box spring

The throw pillow is <u>on top of</u> the bedspread.
The box spring is <u>underneath</u> the mattress.

The comforter is the flat sheet.
The fitted sheet is the flat sheet.
The carpet is the bed.
The mattress is the box spring.

THE BATHROOM

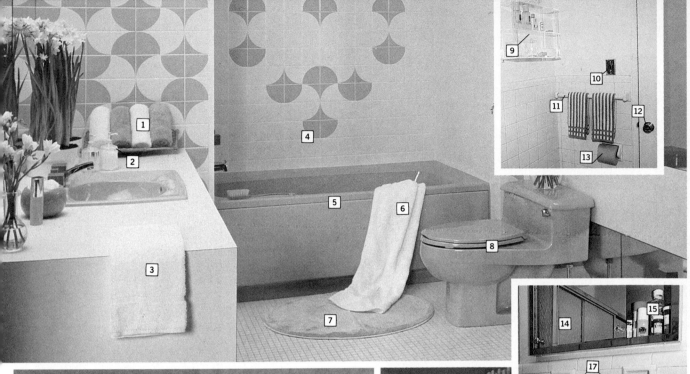

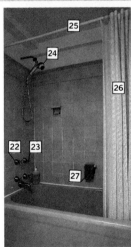

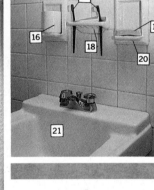

1. guest towel
2. soap dispenser
3. hand towel
4. tile
5. bathtub/tub
6. bath towel
7. bath mat/bath rug
8. toilet
9. shelf
10. light switch
11. towel rack
12. doorknob
13. toilet paper
14. mirror

15. medicine cabinet
16. cup
17. toothbrush
18. toothbrush holder
19. soap
20. soap dish
21. sink
22. hot water faucet
23. cold water faucet
24. shower head
25. shower curtain rod
26. shower curtain
27. washcloth

Where's the medicine cabinet?
It's <u>above</u> the sink.

Where's the sink?
It's <u>below</u> the medicine cabinet.

Where's the light switch?
It's the towel rack.

Where's the toilet paper?
It's the towel rack.

Where's the soap dish?
It's the medicine cabinet.

Where's the cup?
It's the sink.

THE KITCHEN

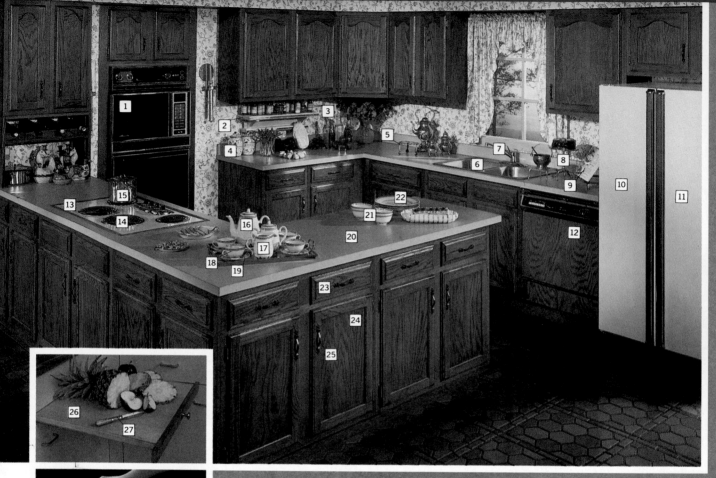

1. oven
2. spice rack
3. spices
4. canister
5. trivet
6. sink
7. faucet
8. cake stand

9. cookbook
10. freezer
11. refrigerator
12. dishwasher
13. stove/range
14. burner
15. (copper) pot
16. coffee pot

17. creamer
18. cup
19. saucer
20. counter
21. bowl
22. plate
23. drawer
24. cupboard/cabinet

25. (door) handle
26. cutting board
27. (paring) knife
28. dish towel
29. Saran wrap/ plastic wrap
30. aluminum foil
31. pot holder

Where's the canister?
It's <u>on</u> the counter.

Where's the bowl?
It's <u>next to</u> the plate.

Where's the cup?
It's the saucer.

Where's the dishwasher?
It's the freezer.

Where's the pot?
It's the stove.

KITCHENWARE

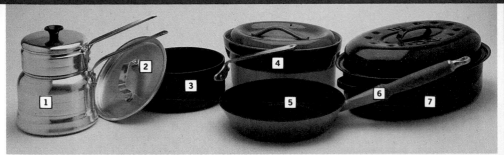

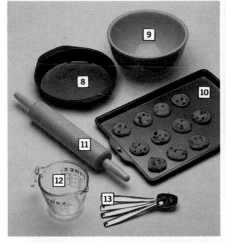

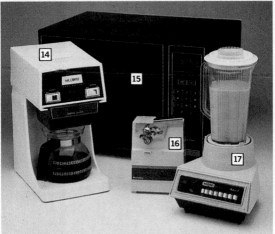

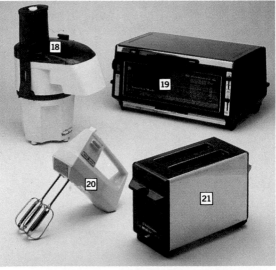

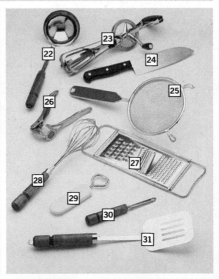

1. double boiler
2. lid/cover
3. pot
4. casserole
5. frying pan/skillet
6. handle
7. roaster
8. cake pan
9. bowl
10. cookie sheet
11. rolling pin
12. measuring cup
13. measuring spoon
14. coffee maker
15. microwave oven
16. can opener
17. blender
18. food processor
19. toaster oven
20. (electric) mixer
21. toaster
22. ladle
23. (hand) beater/egg beater
24. knife
25. strainer
26. garlic press
27. grater
28. whisk
29. bottle opener
30. peeler
31. spatula

What's a <u>toaster</u> for?	For making toast.		

| What's a for? | For making cookies. |? | For making roasts. |
| What's a for? | For making coffee. |? | For opening cans. |

46

THE NURSERY

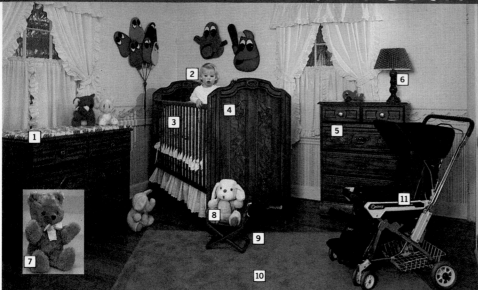

1. changing pad
2. child
3. bar
4. crib
5. chest (of drawers)
6. lamp
7. teddy bear
8. stuffed animal
9. baby chair
10. rug
11. stroller
12. baby/infant
13. baby carrier
14. carriage
15. car seat
16. highchair
17. playpen
18. baby seat
19. bib
20. nipple
21. (baby) bottle
22. cap/top
23. food warmer
24. (baby) clothes
25. diaper

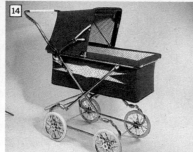

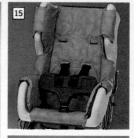

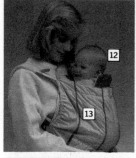

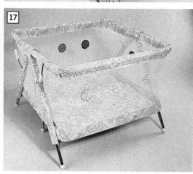

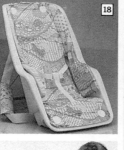

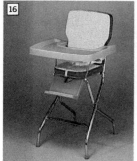

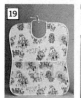

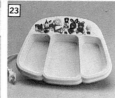

17 Put the baby in the playpen.
19 Put the bib on the baby.

11 Put the baby in the
25 Put the on the baby.

16 Put the baby in the
24 Put the on the baby.

THE PLAYGROUND

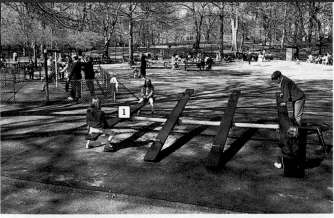

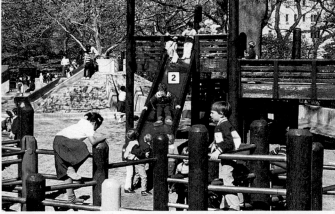

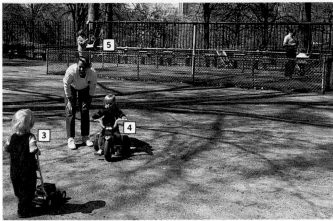

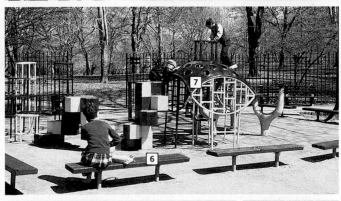

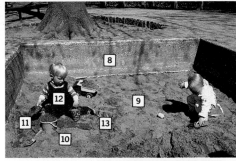

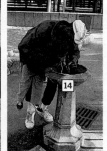

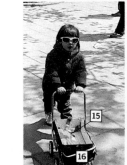

1. see-saw/teeter-totter
2. slide
3. toddler/child
4. tricycle
5. swing
6. bench
7. jungle gym
8. sandbox
9. sand
10. pail
11. shovel
12. overalls
13. sneakers
14. water fountain
15. doll
16. doll carriage
17. skateboard
18. kite

| Where is he? | 4 | He's on the tricycle. |
| Where is she? | 6 | She's on the bench. |

Where is he?	7	He's
Where is she?	1	She's
..........?	2
..........?	17

48

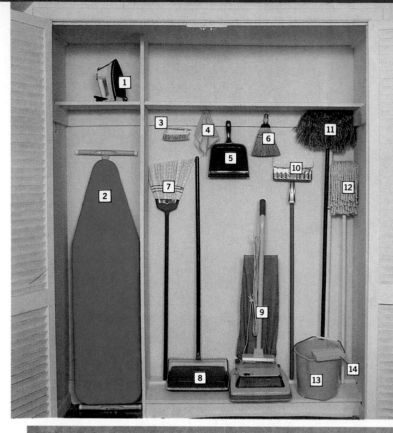
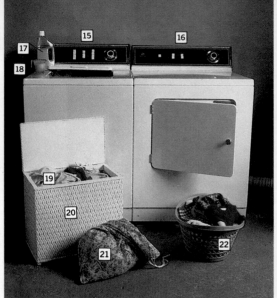
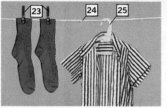
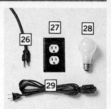

1. iron
2. ironing board
3. scrub brush
4. dust cloth
5. dustpan
6. whisk broom
7. broom
8. carpet sweeper

9. vacuum cleaner
10. (sponge) mop
11. (dust) mop
12. (wet) mop
13. bucket/pail
14. sponge
15. washer/washing machine

16. dryer
17. detergent
18. measuring cup
19. laundry
20. hamper
21. laundry bag
22. laundry basket

23. clothespin
24. clothesline
25. hanger
26. three-pronged plug
27. (wall) socket/outlet
28. bulb
29. extension cord

The carpet sweeper is <u>to the right of</u> the broom.
The broom is <u>to the left of</u> the carpet sweeper.

The broom is the ironing board.
The vacuum cleaner is the sponge mop.
The wet mop is the dust mop.

The dust pan is the whisk broom.
The is to the left of the
The is to the right of the

TOOLS

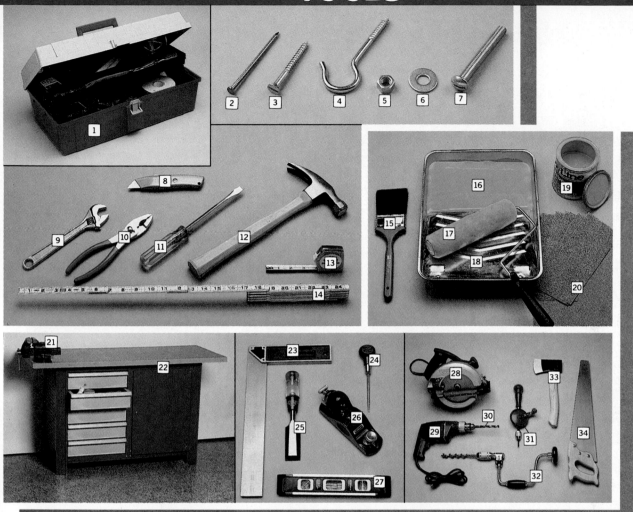

1. toolbox	8. utility knife	15. paintbrush/brush	22. workbench	29. electric drill
2. nail	9. wrench	16. paint	23. square	30. bit
3. screw	10. pliers	17. (paint) roller	24. awl	31. hand drill
4. hook	11. screwdriver	18. pan	25. chisel	32. brace
5. nut	12. hammer	19. (paint) can	26. plane	33. hatchet
6. washer	13. tape measure	20. sandpaper	27. level	34. saw
7. bolt	14. folding rule	21. vise	28. power saw	

Have you ever used a <u>hammer</u>?	Yes, I have./No, I haven't.
Have you ever used an <u>awl</u>?	Yes, I have./No, I haven't.

Have you ever used a? ?
Have you ever used a?

ELECTRONICS

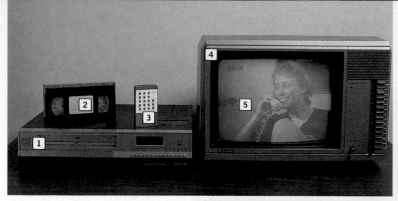

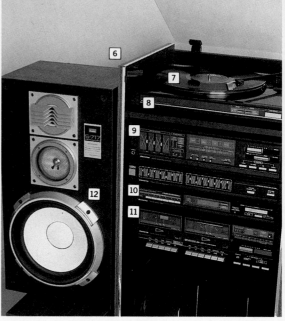
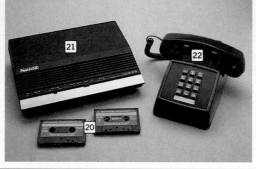
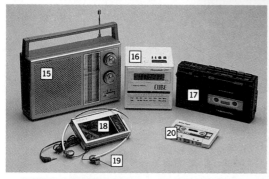

1. video cassette recorder/VCR
2. (video) cassette
3. remote control
4. television/TV
5. screen
6. stereo system
7. record
8. turntable
9. amplifier
10. tuner
11. tape deck/cassette deck
12. speaker
13. compact disc player
14. compact disc/CD
15. radio
16. clock radio
17. tape recorder/cassette player
18. personal cassette player/Walkman
19. headphone
20. (audio) cassette/tape
21. answering machine
22. telephone

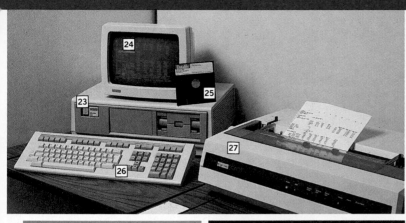
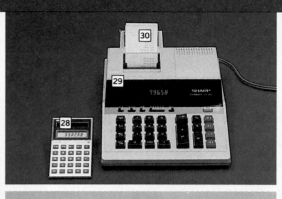
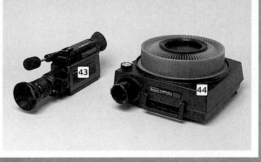
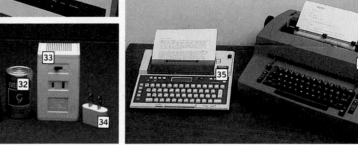
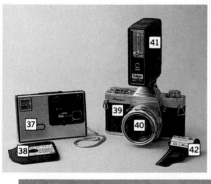

23. computer	34. plug converter
24. display screen/monitor	35. electronic typewriter
25. floppy disc/diskette	36. electric typewriter
26. keyboard	37. disc camera
27. printer	38. disc film
28. pocket calculator	39. camera
29. calculator	40. lens
30. tape	41. flash
31. adapter	42. film
32. battery	43. video camera
33. voltage converter	44. slide projector

Would you like to have an <u>answering machine</u>?
Yes, I would./No, I wouldn't. I'd rather have a <u>tape recorder</u>.

Would you like to have a? Would you like to have a? ?
...........

CONSTRUCTION

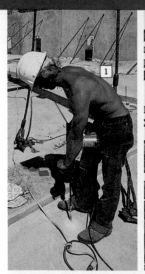
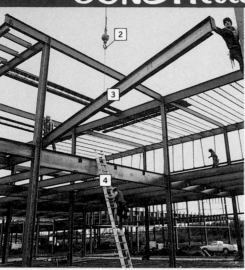
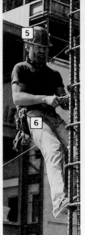
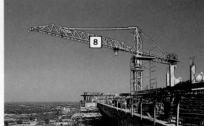
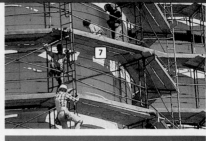
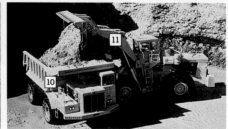

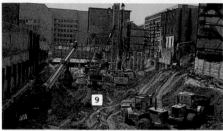
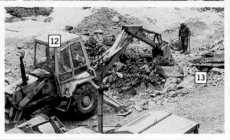
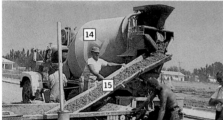
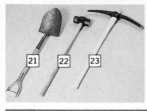

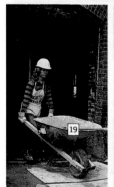

1. construction worker
2. hook
3. girder
4. ladder
5. hard hat
6. tool belt
7. scaffold
8. crane
9. excavation site
10. dump truck
11. frontend loader
12. backhoe
13. blasting mat
14. cement mixer
15. cement
16. trowel
17. brick
18. level
19. wheelbarrow
20. jack hammer/ pneumatic drill
21. shovel
22. sledge hammer
23. pick ax

[8] Have you ever seen a <u>crane</u>?
Yes, I have./No, I haven't.

[12] Have you ever seen a?
..........

[9] Have you ever seen an?
..........

[10]?
..........

53

LAND & WATER

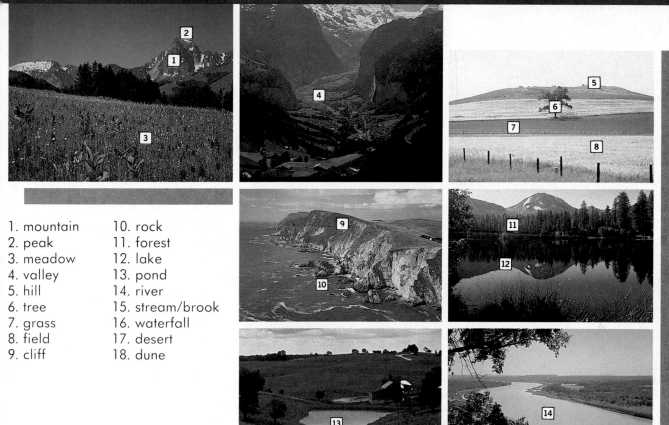

1. mountain
2. peak
3. meadow
4. valley
5. hill
6. tree
7. grass
8. field
9. cliff
10. rock
11. forest
12. lake
13. pond
14. river
15. stream/brook
16. waterfall
17. desert
18. dune

1 Are there any <u>mountains</u> near here?
　Yes, there are./No, there aren't.

5 Are there any near here?
...........

12 Are there any near here?
...........

14?
...........

THE CAR

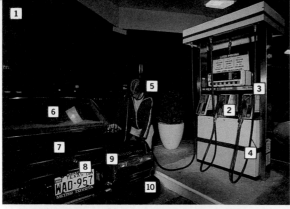

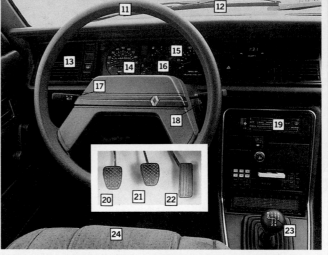

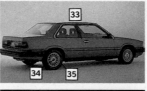

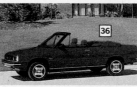

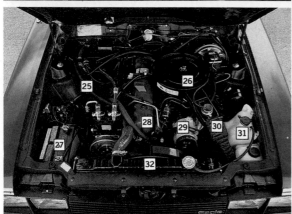

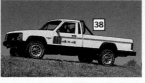

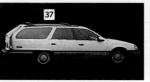

1. gas station
2. gas pump
3. nozzle
4. hose
5. attendant
6. (rear) windshield
7. trunk
8. license plate
9. taillight
10. bumper

11. steering wheel
12. windshield wiper
13. dashboard/
 instrument panel
14. speedometer
15. fuel gauge
16. temperature gauge
17. turn signal
18. ignition
19. heater

20. clutch
21. brake
22. gas pedal/
 accelerator
23. gearshift
24. seat
25. heater hose
26. air filter
27. battery
28. engine

29. alternator
30. cool air duct
31. coolant recovery tank
32. radiator
33. sedan
34. hubcap
35. tire
36. convertible
37. station wagon
38. pick-up truck

What's that called — a <u>hubcap</u> or a <u>tire</u>? [35] It's a <u>tire</u>.

What's that called — a clutch or a brake? [21] It's a
What's that called — a fuel gauge or a temperature gauge? [15] It's a
What's that called — a convertible or a sedan? [33]
What's that called — a battery or a radiator? [27]

THE TRAIN, BUS & TAXI

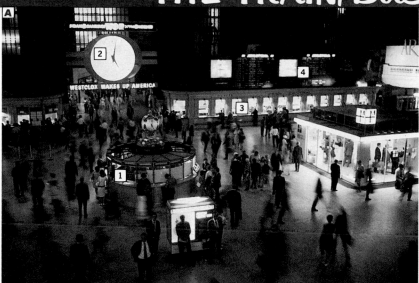

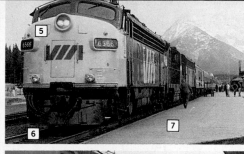

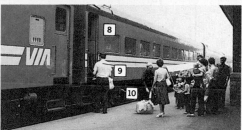

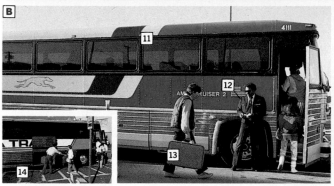

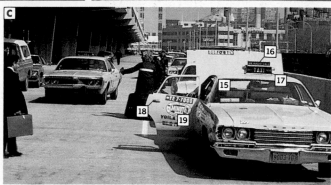

A. The Train Station
1. information booth
2. clock
3. ticket counter
4. arrival and departure board
5. train
6. track
7. platform
8. passenger car
9. porter/redcap
10. passenger

B. The Bus Station
11. bus
12. driver
13. suitcase
14. luggage compartment

C. The Taxi Stand
15. taxi
16. radio call sign
17. off-duty sign
18. (door) handle
19. door

D. Schedule

PELHAM TO NEW YORK

MONDAY TO FRIDAY, EXCEPT HOLIDAYS

Leave	Arrive	Leave	Arrive	Leave	Arrive
Pelham	New York	Pelham	New York	Pelham	New York
AM	AM	AM	AM	PM	PM
5:32	6:00	F10:40	F11:10	FY 5:33	F 6:03
6:02	6:30	11:03	11:33	6:03	6:33
6:32	7:00	11:33	12:03	F 6:33	F 7:03
6:52	7:20	12:03	12:33	7:03	7:33
7:12	7:40	F12:33	F 1:03	F 7:33	F 8:03
7:28	X 8:00	1:03	1:33	Y 8:00	8:33
F 7:44	8:14	1:33	2:03	F 8:33	F 9:03
7:59	8:28	2:03	2:33	9:03	9:33
8:17	8:46	F 2:33	3:03	9:33	10:03
F 8:32	F 9:01	3:03	3:33	F10:33	F11:03
F 9:05	F 9:36	F 3:33	F 4:03	11:33	12:03
F 9:22	F 9:52	4:03	4:33	12:58	1:28
9:43	10:12	F 4:33	F 5:03		
F10:03	F10:33	Y 5:03	5:33		
AM	AM	PM	PM	AM	AM

SATURDAY, SUNDAY & HOLIDAYS

Leave	Arrive	Leave	Arrive	Leave	Arrive
AM	AM	PM	PM	PM	PM
7:03	7:33	12:33	1:03	6:33	7:03
8:03	8:33	F 1:33	2:03	F 7:33	F 8:03
F 8:33	F 9:03	F 2:33	3:03	8:33	9:03
S 9:03	S 9:33	3:33	F 4:03	F 9:33	F10:03
F 9:33	F10:03	4:33	5:03	10:33	11:03
F10:33	F11:03	S 5:03	S 5:33	11:33	12:03
F11:33	F12:03	F 5:33	6:03	12:58	1:28
AM	PM	PM	PM	AM	AM

Where should we meet?	**A**	At the train station.
Where should we meet?	**5**	On the train.

Where should we meet?	**B** At the?	**7** On the
Where should we meet?	**11** On the?	**1** At the

ROUTES & ROAD SIGNS

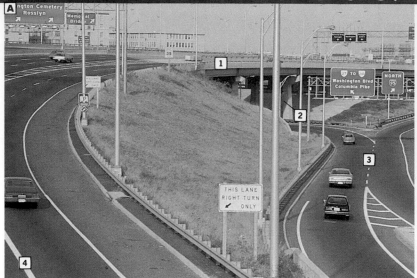

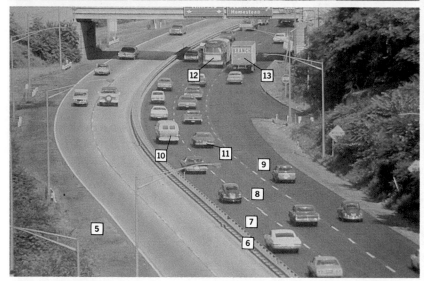

A. Highway

1. overpass
2. underpass
3. broken line
4. solid line
5. shoulder
6. divider
7. left lane
8. middle lane
9. right lane
10. van
11. car
12. bus
13. truck

B. Tollgate

14. tollbooth
15. exact change lane
16. change lane

C. Tunnel

17. street light

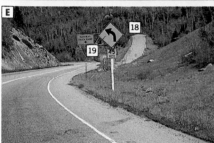

D. Bridge

E. Road
18. dirt road
19. curve sign
20. double yellow lines

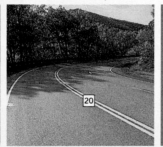

F. Intersection
21. crosswalk
22. street
23. corner

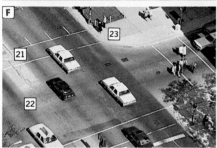

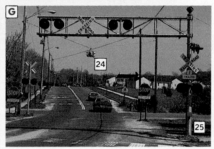

G. Railroad Crossing
24. traffic light
25. railroad track

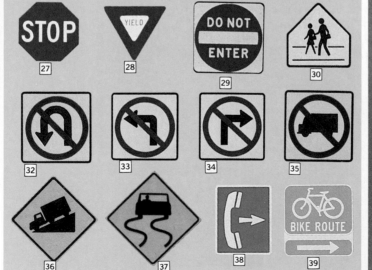

H. Road Signs
26. route sign
27. stop sign
28. yield sign
29. do not enter sign
30. school crossing sign
31. speed limit sign
32. no U-turn sign
33. no left turn sign
34. no right turn sign
35. no trucks sign
36. hill sign
37. slippery when wet sign
38. telephone sign
39. bike route sign

Is that a <u>stop sign</u>? **27** Yes, it is.
Is that a <u>route sign</u>? **31** No, it isn't. It's a <u>speed limit sign</u>.

Is that a yield sign? **28** Is that a telephone sign? **38**
Is that a bike route sign? **30** Is that a hill sign? **37**

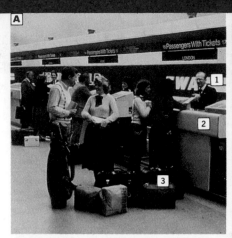

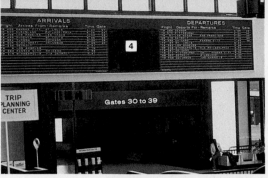

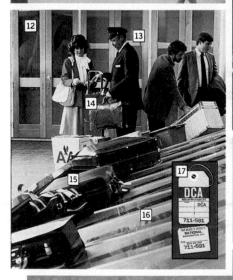

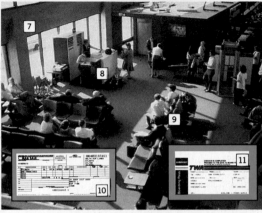

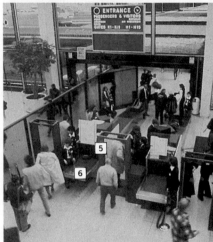

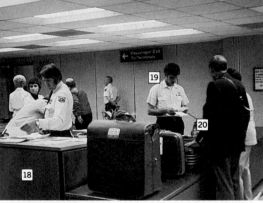

A. The Terminal

1. ticket agent
2. ticket counter
3. suitcase
4. arrival and departure board
5. security check
6. security guard
7. gate
8. check-in counter
9. waiting room
10. ticket
11. boarding pass
12. baggage claim area
13. porter/skycap
14. luggage carrier
15. luggage
16. (luggage) carousel
17. (baggage) claim check
18. customs
19. customs officer
20. documents
21. passport

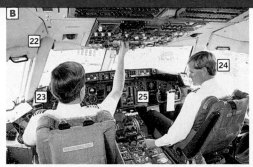

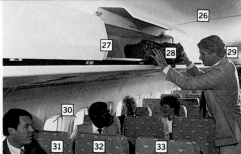

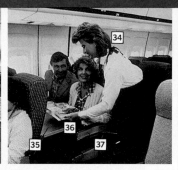

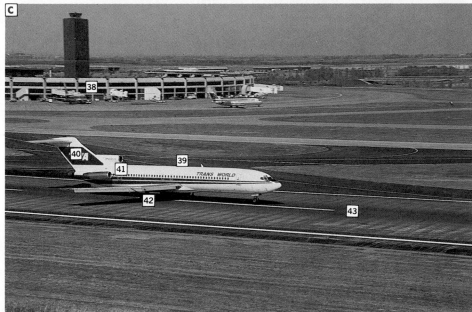

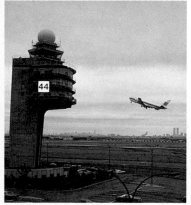

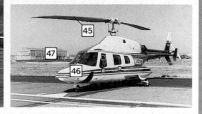

B. On Board

22. cockpit
23. pilot/captain
24. co-pilot
25. instrument panel
26. cabin
27. overhead (luggage) compartment
28. carry-on luggage/ carry-on bag
29. passenger
30. window
31. window seat
32. middle seat
33. aisle seat
34. flight attendant
35. tray table
36. tray
37. armrest

C. The Runway

38. terminal
39. jet (plane)
40. tail
41. jet engine
42. wing
43. runway
44. control tower
45. rotor
46. helicopter
47. hangar

Where's the ticket agent?	☐2 He's <u>at the ticket counter</u>.
Where's the pilot?	☐22 He's <u>in the cockpit</u>.
Where's the tray?	☐35 It's <u>on the tray table</u>.

Where's the security guard? ☐5 He's at the
Where's the check-in counter? ☐7 It's at the
Where's the passenger? ☐26 He's in the

Where's the carry-on bag? ☐27 It's in the
Where's the luggage? ☐16 It's on the
Where's the plane? ☐43 It's on the

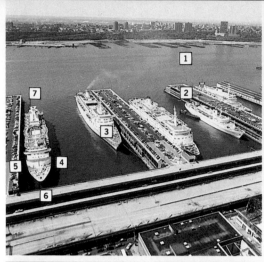

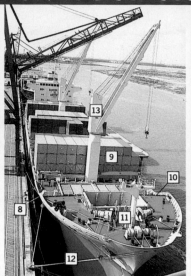

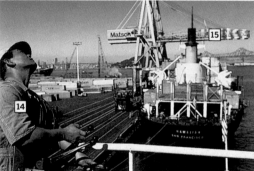

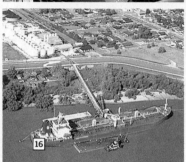

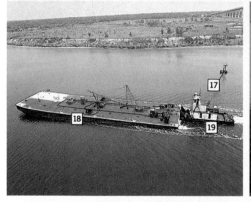

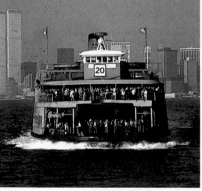

1. harbor
2. pier/dock
3. passenger ship/ocean liner
4. port
5. starboard
6. bow
7. stern
8. cargo ship/freighter
9. cargo
10. deck
11. winch
12. line
13. derrick
14. dock worker/longshoreman
15. crane
16. (oil) tanker
17. buoy
18. barge
19. tugboat
20. ferry

[3] Have you ever been on a <u>passenger ship</u>?
Yes, I have./No, I haven't.

[19] Have you ever been on a?
..........

[20] Have you ever been on a?
..........

[8]?
..........

THE BEACH

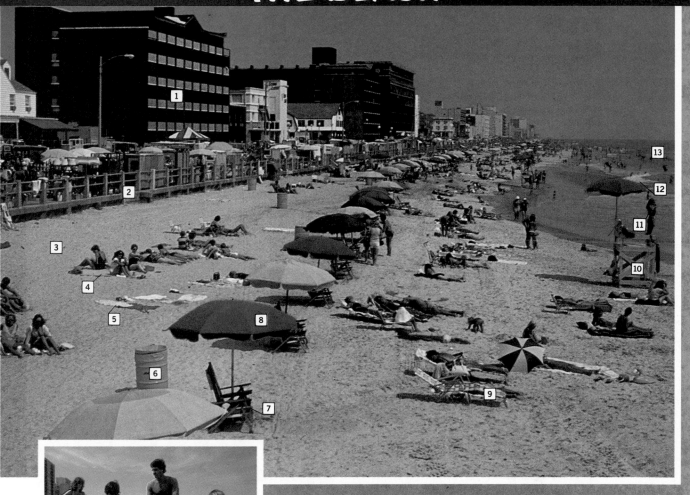

1. hotel
2. boardwalk
3. sand
4. (beach) blanket
5. (beach) towel
6. trash can
7. (beach) chair
8. (beach) umbrella
9. lounge chair
10. lifeguard stand

11. lifeguard
12. wave
13. ocean
14. (beach) ball
15. (beach) hat/sun hat
16. sand castle
17. bathing suit
18. pail/bucket
19. seashell
20. rock

Do you usually take a <u>hat</u> to the beach?	Yes, I do./No, I don't.
Do you usually take an <u>umbrella</u> to the beach?	Yes, I do./No, I don't.

Do you usually take a to the beach?
Do you usually take a to the beach?
..........?

WATER SPORTS

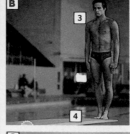

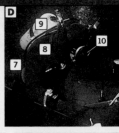

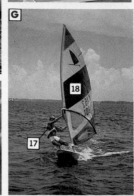
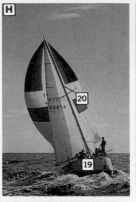
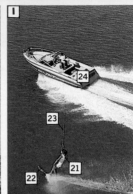
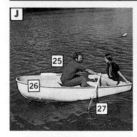
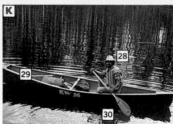
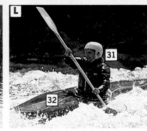
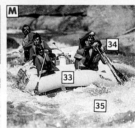

A. Swimming
1. swimmer
2. swimming pool

B. Diving
3. diver
4. diving board

C. Snorkeling
5. snorkeler
6. snorkel

D. Scuba Diving
7. scuba diver
8. wet suit

9. (air) tank
10. mask

E. Fishing
11. fisherman
12. fishing rod
13. (fishing) line

F. Surfing
14. surfer
15. surf
16. surfboard

G. Windsurfing
17. windsurfer
18. sail

H. Sailing
19. sailboat
20. mast

I. Waterskiing
21. water-skier
22. water ski
23. towrope
24. motorboat

J. Rowing
25. rower
26. rowboat
27. oar

K. Canoeing
28. canoeist
29. canoe
30. paddle

L. Kayaking
31. kayaker
32. kayak

M. White Water Rafting
33. raft
34. life jacket
35. rapids

Does a canoeist use a <u>paddle</u>?	30	Yes, he does.
Does a rower use a <u>paddle</u>?	27	No, he doesn't. He uses an <u>oar</u>.

Does a surfer use a surfboard? 16 Does a scuba diver use a life jacket? 8
Does a fisherman use a mask? 12 Does a water-skier use a towrope? 23

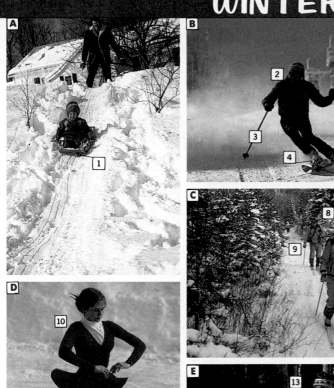

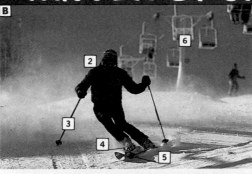

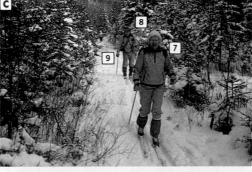

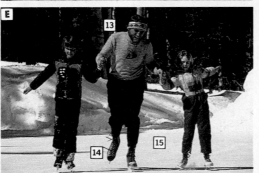

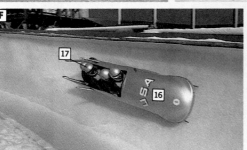

A. Sledding
1. sled

B. Downhill Skiing
2. skier
3. pole
4. (ski) boot
5. ski
6. chair lift

C. Cross Country Skiing
7. skier
8. ski cap
9. trail

D. Figure Skating
10. figure skater
11. figure skate
12. blade

E. Ice Skating
13. skater
14. skate
15. ice

F. Bobsledding
16. bobsled
17. helmet

G. Snowmobiling
18. snowmobile

Do you prefer <u>downhill skiing</u> or <u>cross country skiing</u>?
I prefer <u>downhill skiing</u>.

Do you prefer sledding or snowmobiling?
I prefer

Do you prefer or?
I prefer

..........?
..........

64

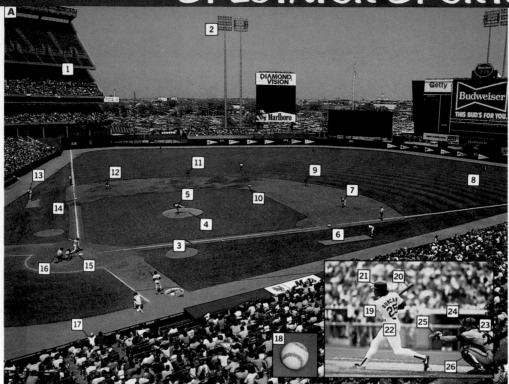

15. home (plate)
16. umpire
17. spectator
18. baseball
19. batter
20. bat
21. helmet
22. uniform
23. catcher
24. mask
25. (baseball) glove/mitt
26. shin guard

B. Football
27. (football) field
28. fullback/
 runningback
29. halfback/
 runningback
30. right end/
 wide receiver
31. tight end
32. right tackle
33. right guard
34. center
35. quarterback
36. left guard
37. left tackle
38. left end/
 wide receiver
39. football

A. Baseball
1. stadium
2. stadium lights
3. foul line
4. (pitcher's) mound
5. pitcher
6. first base
7. first baseman
8. outfielder
9. second baseman
10. second base
11. shortstop
12. third baseman
13. coach
14. third base

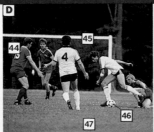

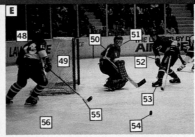

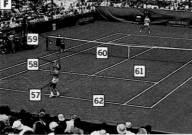

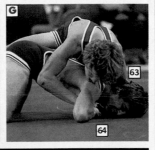

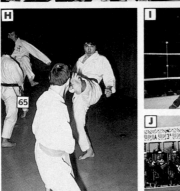

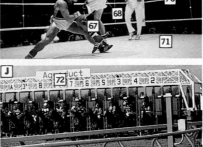

50. goalie
51. mask
52. glove
53. skate
54. puck
55. (hockey) stick
56. ice

F. Tennis

57. (tennis) player
58. (tennis) racket
59. (tennis) ball
60. net
61. (tennis) court
62. baseline

G. Wrestling

63. wrestler
64. mat

H. Karate

65. (black) belt

I. Boxing

66. boxer
67. (boxing) glove
68. trunks
69. referee
70. rope
71. ring

J. Horse Racing

72. gate

C. Basketball

40. (basketball) player
41. basketball
42. backboard
43. basket

D. Soccer

44. (soccer) player
45. goal
46. (soccer) ball
47. (soccer) field

E. Ice Hockey

48. (hockey) player
49. goal

B Do they play <u>football</u> in your country?
Yes, they do./No, they don't. They play <u>soccer</u>.

C Do they play in your country?
...........

A Do they play in your country?
...........

E?
...........

66

OTHER SPORTS

A. Jogging
1. jogger

B. Running
2. runner

C. Cycling
3. cyclist
4. helmet
5. bicycle/bike
6. (bicycle) pack
7. wheel

D. Horseback Riding
8. (horseback) rider
9. horse
10. reins
11. saddle
12. stirrup

E. Archery
13. archer
14. bow
15. arrow
16. target

F. Golf
17. golfer
18. (golf) club
19. (golf) ball
20. hole
21. green

G. Hiking
22. hiker
23. backpack
24. hiking boot
25. trail

H. Camping
26. camper
27. tent

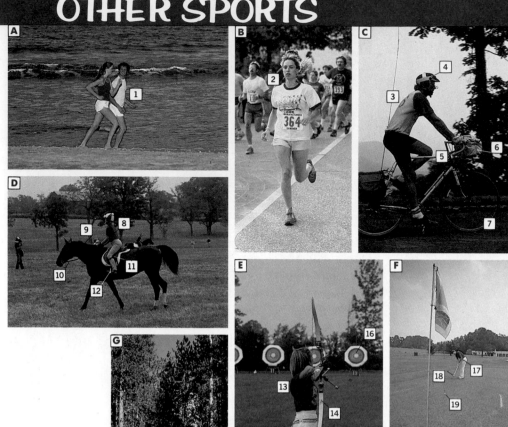

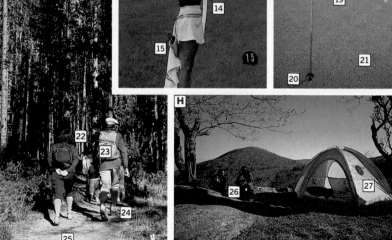

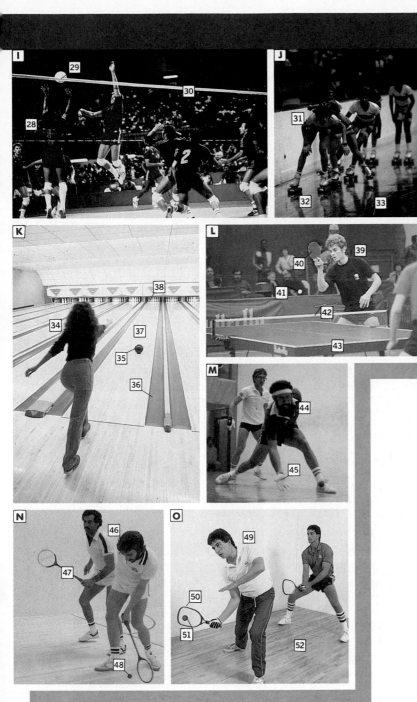

I. Volleyball
28. (volleyball) player
29. volleyball
30. net

J. Rollerskating
31. roller skater
32. roller skate
33. rink

K. Bowling
34. bowler
35. (bowling) ball
36. gutter
37. alley
38. pin

L. Ping Pong / Table Tennis
39. (ping pong) player
40. paddle
41. (ping pong) ball
42. net
43. (ping pong) table

M. Handball
44. (handball) player
45. glove

N. Squash
46. (squash) player
47. (squash) racket
48. (squash) ball

O. Racquetball
49. (racquetball) player
50. (racquetball) racket
51. racquetball
52. court

Do you like jogging?
Yes, I do./No, I don't. I prefer cycling.

Do you like? Do you like? ?
..........

ENTERTAINMENT

A. Symphony
1. orchestra
2. podium
3. conductor
4. (sheet) music
5. music stand

B. Opera
6. chorus
7. singer

C. Ballet
8. ballerina
9. ballet dancer
10. toe shoe

D. Theater
11. actress
12. actor
13. stage
14. audience
15. aisle
16. spotlight
17. footlights
18. orchestra pit

E. Movie Theater
19. marquee
20. billboard

F. Rock Concert
21. singer/vocalist

C Have you ever been to a <u>ballet</u>?
Yes, I have./No, I haven't.

E Have you ever been to a?
..........

F?
..........

B Have you ever been to an?
..........

A?
..........

MUSICAL INSTRUMENTS

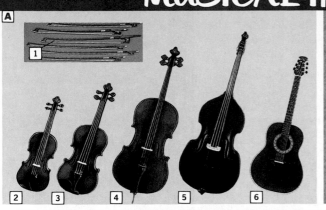

A. Strings
1. bow
2. violin
3. viola
4. cello
5. bass
6. guitar

B. Brass
7. trombone
8. French horn
9. tuba
10. trumpet

C. Woodwinds
11. flute
12. recorder
13. oboe
14. clarinet
15. saxophone
16. bassoon

D. Percussion
17. cymbal
18. drum
19. xylophone

E. Other Instruments
20. piano
21. accordion
22. harmonica

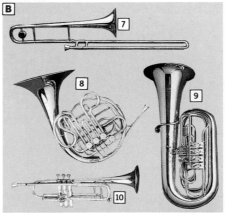

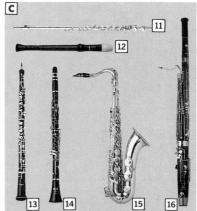

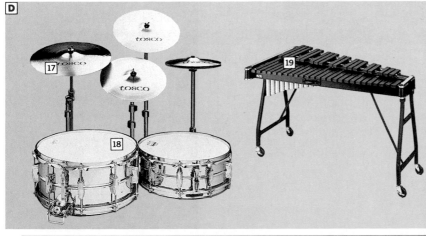

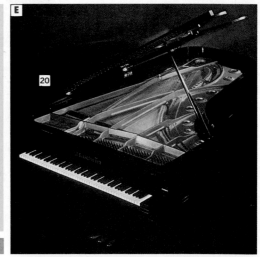

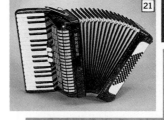

The cello is <u>larger than</u> the violin.
The recorder is <u>smaller than</u> the flute.

The French horn is the trumpet.
The harmonica is the accordion.
The violin is the cello.
The bass is the viola.

THE ZOO & PETS

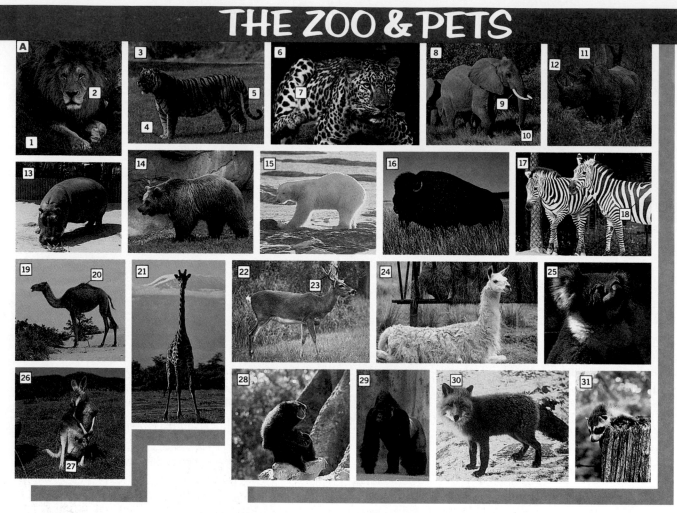

A. The Zoo

1. lion
2. mane
3. tiger
4. paw
5. tail
6. leopard
7. spot

8. elephant
9. tusk
10. trunk
11. rhinoceros
12. horn
13. hippopotamus
14. bear
15. polar bear

16. buffalo
17. zebra
18. stripe
19. camel
20. hump
21. giraffe
22. deer
23. antler

24. llama
25. koala bear
26. kangaroo
27. pouch
28. monkey
29. gorilla
30. fox
31. raccoon

Do zebras have <u>stripes</u>? ⓲ Yes, they do.
Do leopards have <u>stripes</u>? ⑦ No, they don't. They have <u>spots</u>.

Do lions have manes? ②
Do elephants have manes? ⑩
Do rhinoceroses have antlers? ⑫

Do camels have humps? ⑳
..........?

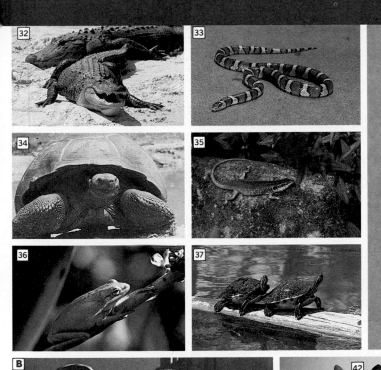

32. alligator
33. snake
34. tortoise
35. lizard
36. frog
37. turtle

B. Pets

38. puppy
39. dog
40. paw
41. kitten

42. cat
43. whiskers
44. parrot
45. parakeet
46. gerbil
47. tail
48. hamster
49. guinea pig
50. rabbit
51. goldfish
52. (fish) bowl
53. tropical fish

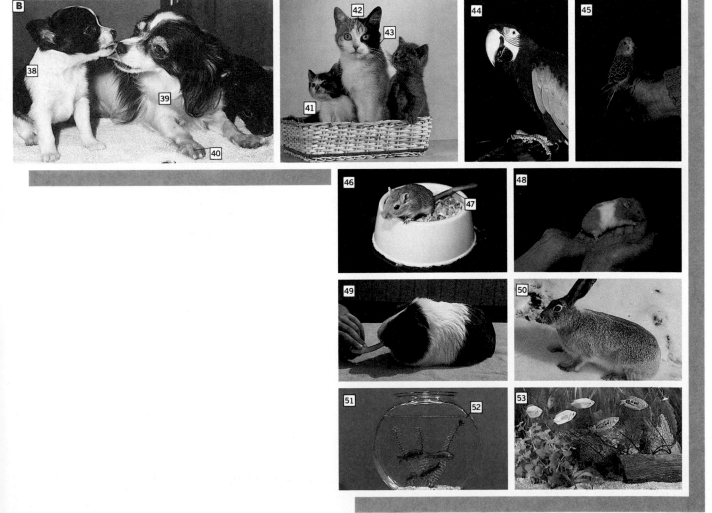

THE FARM

 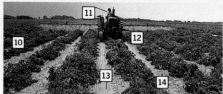

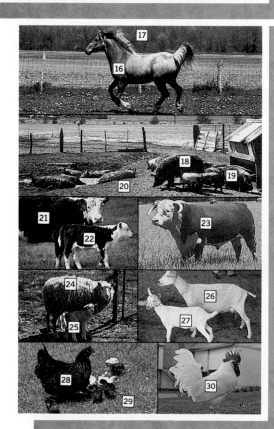

1. farmland
2. farmhouse
3. barn
4. silo
5. barnyard
6. fence
7. pond
8. wheat field
9. combine
10. vegetable field

11. farmer
12. tractor
13. furrow
14. crop
15. irrigation system
16. horse
17. mane
18. pig
19. piglet
20. pigpen/pig sty

21. cow
22. calf
23. bull
24. sheep
25. lamb
26. goat
27. kid
28. chicken/hen
29. chick
30. rooster

A calf is <u>younger than</u> a cow.
A goat is <u>older than</u> a kid.

A chick is a hen.
A goat is a kid.
A pig is
A lamb is
A cow is

FISH & SEA ANIMALS

A. Fish

1. shark
2. snout
3. fin
4. tail
5. bass
6. scale
7. trout
8. gill
9. angelfish
10. sunfish
11. eel

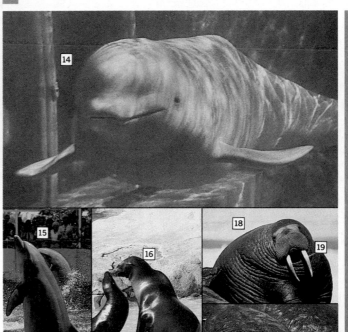

B. Sea Animals

12. octopus
13. tentacle
14. whale
15. dolphin
16. seal
17. flipper
18. walrus
19. tusk
20. turtle
21. lobster
22. shrimp
23. mussel
24. crab
25. claw
26. clam
27. starfish

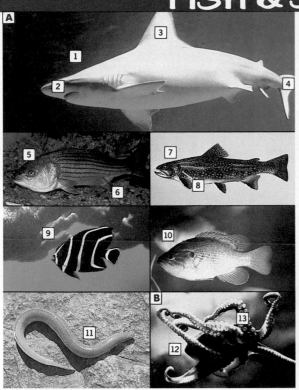

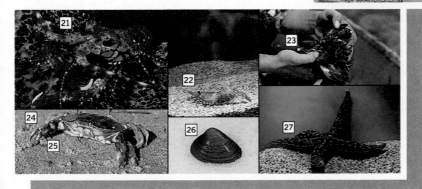

Which is the biggest—the <u>turtle</u>, the <u>walrus</u> or the <u>whale</u>?
The <u>whale</u> is the biggest.

Which is the biggest—the lobster, the crab or the shrimp?
The is the biggest.

Which is the biggest—the mussel, the clam or the starfish?
The is the biggest.

Which is the biggest—the shark, the trout or the angelfish?
..........

BIRDS

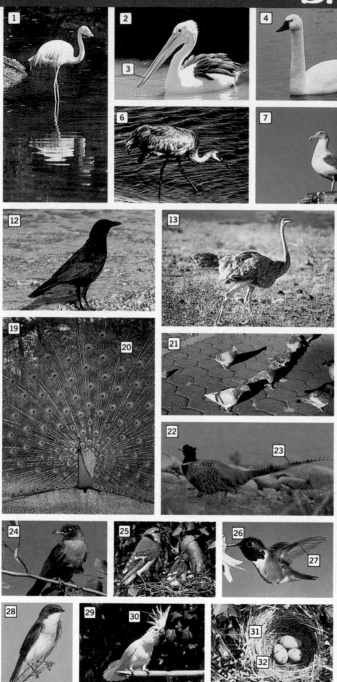

1. flamingo	17. claw
2. pelican	18. owl
3. bill	19. peacock
4. swan	20. feather
5. stork	21. pigeon
6. crane	22. pheasant
7. gull	23. tail
8. duck	24. robin
9. duckling	25. blue jay
10. penguin	26. hummingbird
11. flipper	27. wing
12. crow	28. swallow
13. ostrich	29. cockatoo
14. eagle	30. crest
15. beak	31. nest
16. hawk	32. egg

Is the swan <u>prettier than</u> the pelican?
Yes, it is./No, it isn't.

Is the peacock the swallow?
...........

Is the ostrich the flamingo?
...........

...........?
...........

INSECTS & RODENTS

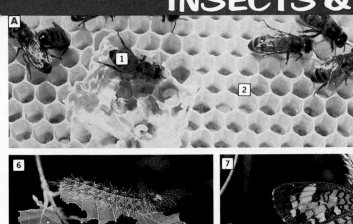

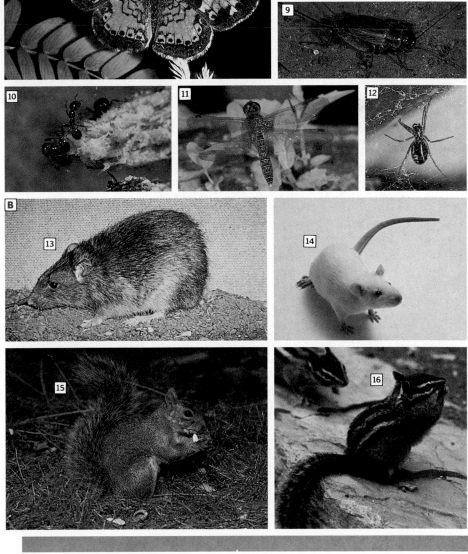

A. Insects

1. bee
2. honeycomb
3. fly
4. mosquito
5. cockroach/roach
6. caterpillar
7. butterfly
8. ladybug
9. cricket
10. ant
11. dragonfly
12. spider*

B. Rodents

13. rat
14. mouse
15. squirrel
16. chipmunk

*not an insect

Is that a <u>bee</u> or a <u>fly</u>? ☐1 It's a <u>bee</u>.

Is that a fly or a mosquito? ☐4 It's a
Is that a rat or a mouse? ☐14 It's a

Is that a squirrel or a chipmunk? ☐15
Is that a caterpillar or a butterfly? ☐6

SPACE

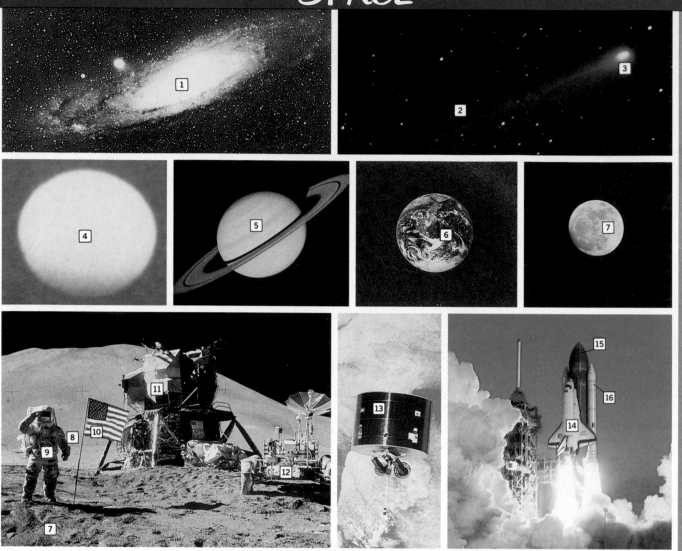

1. galaxy
2. star
3. comet
4. Sun
5. planet/Saturn
6. Earth
7. Moon
8. astronaut
9. space suit
10. flag
11. lunar module
12. lunar vehicle
13. satellite
14. space shuttle
15. fuel tank
16. booster rocket

Have you ever seen a <u>galaxy</u>? Yes, I have./No, I haven't.

Have you ever seen a space shuttle? Have you ever seen a planet?
Have you ever seen a lunar module? Have you ever seen a comet?

THE MILITARY

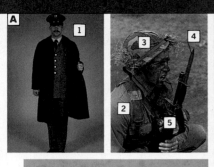

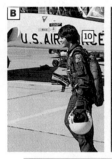

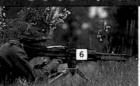

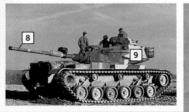

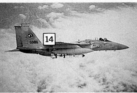

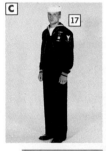

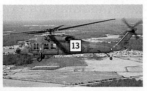

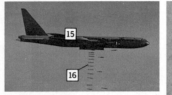

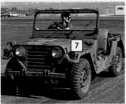

A. Army
1. soldier
2. fatigues
3. camouflage
4. bayonet
5. rifle
6. machine gun
7. jeep
8. cannon
9. tank

B. Air Force
10. pilot
11. parachute
12. parachutist
13. helicopter
14. fighter plane
15. bomber
16. bomb

C. Navy
17. sailor
18. submarine
19. destroyer
20. radar antenna
21. battleship
22. aircraft carrier

D. Marines

Were you ever <u>a soldier</u>?
Yes, I was./No, I wasn't.

Were you ever a pilot?
...........

Were you ever a sailor?
...........

HOBBIES & GAMES

A. Hobbies
1. coin collecting
2. coin
3. (coin) album
4. coin catalog
5. magnifying glass
6. stamp collecting
7. (stamp) album
8. stamp
9. stamp catalog
10. photography
11. camera
12. astronomy
13. telescope
14. bird watching

B. Crafts
15. sculpting
16. sculpture
17. knitting
18. knitting needle
19. weaving
20. loom
21. pottery
22. potter's wheel
23. painting
24. brush
25. woodworking

C. Games
26. chess
27. board
28. checkers
29. backgammon
30. Scrabble
31. Monopoly
32. cards

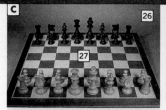
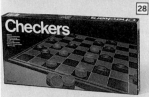
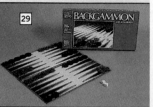
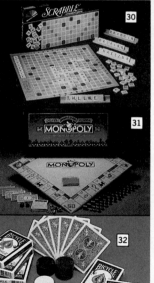
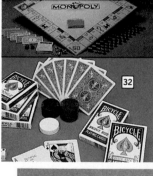

Do you play <u>chess</u>?
Yes, I do./No, I don't, but I play <u>backgammon</u>.

Do you play checkers? Do you play Scrabble? Do you play Monopoly? ?
...........

SEWING & SUNDRIES

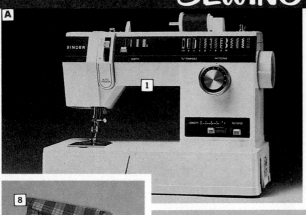

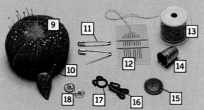

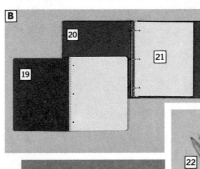

A. Sewing
1. sewing machine
2. sewing basket
3. tape measure
4. yarn
5. knitting needle
6. (pair of) scissors
7. zipper
8. material
9. pin cushion
10. straight pin
11. safety pin
12. needle
13. thread
14. thimble
15. button
16. hook
17. eye
18. snap

B. Sundries
19. (spiral) notebook
20. loose-leaf binder
21. (loose-leaf) paper
22. pencil
23. pencil sharpener
24. protractor
25. compass
26. wrapping paper
27. bow
28. box
29. tissue paper
30. ribbon
31. string
32. masking tape

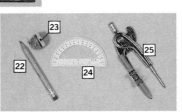

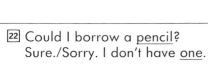

[22] Could I borrow a <u>pencil</u>?
Sure./Sorry. I don't have <u>one</u>.

[21] Could I borrow some <u>paper</u>?
Sure./Sorry. I don't have <u>any</u>.

[12] Could I borrow a?
..........

[32] Could I borrow some?
..........

[11] Could I borrow a?
..........

[13] Could I borrow some?
..........

WORD LIST

The Word List is an alphabetized index of the entries in the Longman Photo Dictionary. The bold number indicates the page on which the word appears; the other numbers refer to the item(s) on the page. For example, "brush **25**-3, 21; **50**-15" means that the word "brush" appears on page 25 in items 3 and 21 as well as on page 50 in item 15.